A–Z

OF

TAUNTON

PLACES - PEOPLE - HISTORY

Andrea Cowan

AMBERLEY

First published 2023

Amberley Publishing
The Hill, Stroud, Gloucestershire, GL5 4EP
www.amberley-books.com

Copyright © Andrea Cowan, 2023

The right of Andrea Cowan to be identified as
the Author of this work has been asserted in
accordance with the Copyrights, Designs and
Patents Act 1988.

ISBN 978 1 4456 9571 6 (print)
ISBN 978 1 4456 9572 3 (ebook)

British Library Cataloguing in Publication Data.
A catalogue record for this book is available
from the British Library.

Origination by Amberley Publishing.
Printed in Great Britain.

Contents

Introduction

Taunton, the county town, has always had a special place in Somerset's history. Lying on the River Tone between the Quantock, Blackdown and Brendon hills in an area known as the Vale of Taunton, it began as the Saxon village 'Tone Tun' (tone meaning river, tun meaning farm or enclosure). Over the centuries it grew in wealth and stature, due in part to its association with the Bishops of Winchester and the prosperity that came with its industrial prowess, from wool to cider.

As with most towns and cities, there is a wealth of architectural features and heritage sites to explore in Taunton: some are obvious, others are more unassuming. The joy of researching a book such as this has been the opportunity to look at the town in a different light; buildings, streets and parks that are walked past every day have come alive with the uncovering of their history and stories.

This A–Z is a collection of some of these features, as well as the people, both famous and infamous, who have played their part in shaping Taunton.

Almshouses

Almshouses were originally built by medieval monasteries to take care of the elderly and frail. In Taunton, a row of almshouses was built on the corner of St James Street and Canon Street in approximately 1500. They were demolished in 1897, but some oak frame timbers were saved and have been used to reconstruct an almshouse outside the Museum of Somerset, in Taunton Castle. It provides a fascinating glimpse into the life of a poor elderly person.

With the Dissolution of the Monasteries in the sixteenth century, many of these buildings were left in a state of disrepair or sold off. It was left to rich benefactors to rise to the challenge.

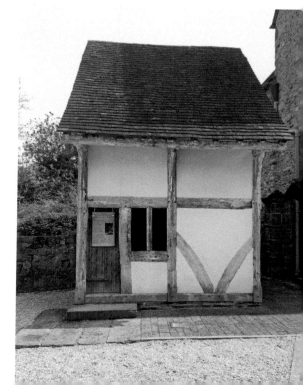

The reconstruction of a sixteenth-century almshouse from St James Street, situated outside the Museum of Somerset.

Gray's Almshouses

A short walk down East Street brings you to Gray's Almshouses founded in 1635 by Robert Gray. Born in Taunton, Gray moved to London where he made his fortune as a cloth merchant and became a member of the Merchant Taylors' Livery Company. As was quite usual for that time, he had intended for the almshouses to be managed by the livery company, but it eventually declined deciding that the distance from London was too great.

The terrace of almshouses was built next to the house in which Gray had been born and is considered one of the oldest brick buildings in Somerset. It was originally designed to provide a dwelling for ten women, with a chapel and a schoolroom. Additional homes for six men were included in 1696 after Gray died, as requested in his will.

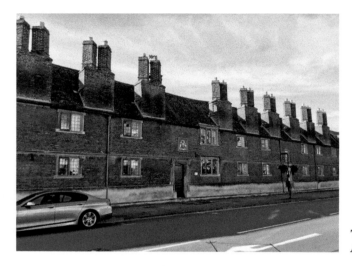

The terrace of Gray's Almshouses on East Street.

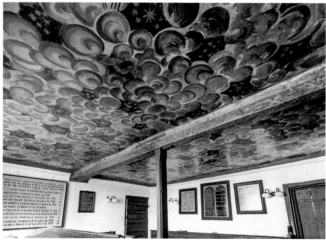

The painted ceiling of the chapel at Gray's Almshouses. (© Taunton Heritage Trust)

The chapel, which can be visited by prior arrangement, still retains its original benches and a striking painted ceiling. The building bears the coat of arms of both Robert Gray and the Merchant Taylors whilst a stone tablet is inscribed with the following

This charitable worke is founded by Robert Graye of the Cittie of London, Esquier, borne in this towne in the howse adioyninge heereunto who in his lyfe tyme doth erect ytt for tenn poore aged syngle women and for ther competent livelihood and daylie prayers in the same hath provided sufficient maintenaunce for the same 1635

Robert Gray has a memorial in St Mary Magdalene Church where he is depicted in richly adorned alderman clothes. The memorial tablet reads:

Consecrated to the blessed memory of Robert Gray e Esq and Founder. Taunton bore him London bred him. Piety trained him, virtue led him. Earth enriched him Heaven carest him. Taunton blest him London blest him. This thankful town. That mindful city. Share his piety and his pity. What he gave and how he gave it. Ask the poor and you shall have it. Gentle reader heaven may strike thy tender heart to do the like now thine eyes have read the story give him the praise and Heaven the glory.

The almshouses are now owned and managed by the Taunton Heritage Trust and currently provide accommodation for seven pensioners.

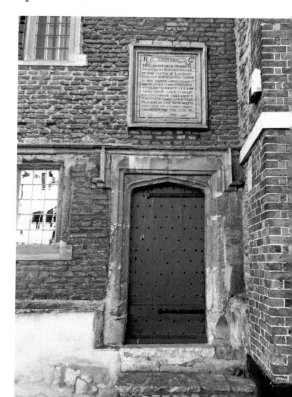

A stone tablet above one of the doors.

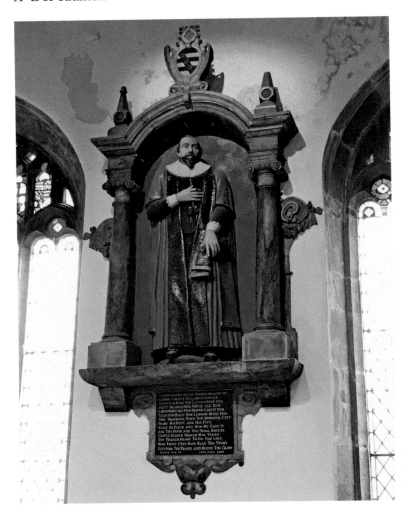

The memorial of
Robert Gray in
St Mary Magdalene
Church.

Huish Homes

The Taunton Heritage Trust also oversees Huish Homes in Magdalene Street, founded in 1615 by Richard Huish, a wealthy wool merchant. It originally provided accommodation for thirteen men, selected for their faith and circumstances. There was to be no gambling or drinking, and in his will, Huish stated that he wanted the ablest of the men to be made president. The almshouse was rebuilt on its current site in 1866.

The Trust now provides sixty-six self-contained flats: Bernard Taylor Homes was built in 1984 on Magdalene Street on the site of Taunton Fire Station; Leycroft Close was built in 1932, a successor to 'Popes Almshouses', which formerly stood next to Gray's Almshouses; and on the edge of St James Churchyard, St James Close Almshouse was built in 1845, thought to replace the fifteenth-century almshouse.

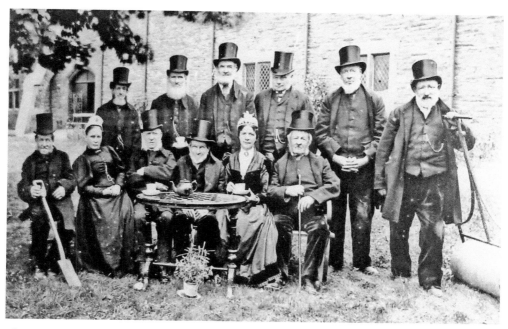

The Huish Homes Almsmen taken *c.* 1890 in the garden to the rear of Magdalene Street. (© Taunton Heritage Trust)

St James Close Almshouse.

Thomas Baker

Thomas Baker was a wealthy grocer who owned No. 15 Fore Street in the seventeenth century. He was the father of Mary and Elizabeth, two of the 'Maids of Taunton' who welcomed the Duke of Monmouth to the town in 1685. His house was also occupied by one of the Monmouth Rebellion Privy Councils.

The Bath & West of England Agricultural Show

In 1848, the Royal Agricultural Society of England held a show in Exeter. The Bath & West of England Agricultural Society, which had been founded in 1777 for the promotion and improvement of local agriculture and related activities, was inspired

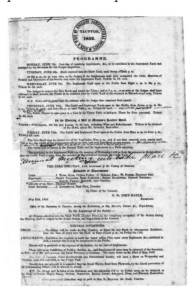

The original Bath & West Show programme. (© The Royal Bath & West of England Society)

to put on their own show. The first one was held in Vivary Park in Taunton and opened to the public on 9 June 1852. There was judging of livestock, and local farmers had the opportunity to see demonstrations of the latest implements from all over Britain.

For the next 100 years, the show toured the country before making Shepton Mallet its home in 1965 and gaining its Royal Patronage in 1977. It is one of the oldest surviving agricultural shows in England and is the only one to take place over four days.

Bath Place

Cutting through from the High Street to Corporation Street is Bath Place, originally named Hunts Court. This narrow, historic, pedestrianised street has a colourful mix of residential cottages and independent businesses.

From the Middle Ages, it was the main thoroughfare to the west of town, until 1894 when Corporation Street was constructed, running roughly parallel to Bath Place and following the lines of the castle's outer moat.

It was widened in the eighteenth century, and most of the buildings date from this time. Many still have their Georgian shopfronts with octagonal glazed fanlights, the small windows over the doors designed to let natural light into the building.

There is an eclectic range of shops, businesses and food and drink establishments, represented by an active Bath Place Traders Association which was established in 1998. Bath Place was shortlisted in the Great British High Street Awards 2015 in the Local Centre category. It's an acknowledgment that the most successful high streets offer a unique experience that people cannot get anywhere else – it's not hard to see why Bath Place did so well.

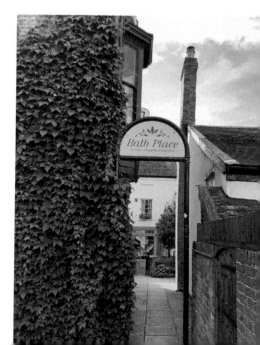

One of the entrances to Bath Place.

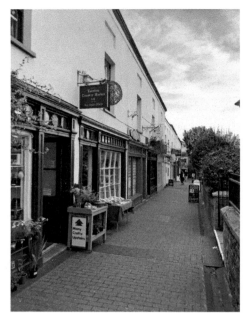

Above left: The historic street of Bath Place, full of independent businesses.

Above right: Many of the establishments on Bath Place still have their original glazed fanlights.

Bridgwater and Taunton Canal

Constructed by engineer James Hollinsworth between 1824 and 1827, the Bridgwater and Taunton Canal was part of an ambitious plan which could potentially link the Bristol and the English Channels. By creating this inland waterway, the perilous sea around Lands End could be avoided when transporting goods.

The original route ran from Taunton, joining the River Parrett at Huntworth and the River Tone at the wharf at Firepool Lock.

By 1841 it was extended to Bridgwater by Thomas Maddicks, an engineer from Devon. It was now possible to travel from Bridgwater to Tiverton by canal.

The canal, approximately 14.5 miles long (23.33 km), with seven locks, enjoyed an initial flush of success, with principal cargoes of coal and iron from South Wales. But its commercial success was short-lived with the arrival of the railways in 1842. Ironically, it was rescued from bankruptcy by the Bristol and Exeter Railway in 1866. Traffic along the canal was discouraged, and the last barge tolls were collected in 1907.

But this was not the end of its use. During the Second World War, the canal was important as part of the Taunton Stop Line (*see* the appropriate section). This was a defensive barrier designed to stop German invaders moving inland if they landed at Minehead or Weston.

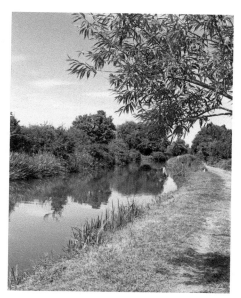

The peaceful canal belies its bustling industrial roots.

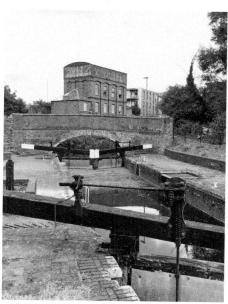

Firepool Lock where the canal and river meet.

In 1962, the canal was taken over by British Waterways (now the Canal & River Trust) and following restoration work it reopened in 1994. Meandering through the Somerset Levels, much of the canal has been designated a Site of Special Scientific Interest because of its populations of rare birds and plants. Its role now is principally for pleasure pursuits: the towpath is a delight to walk; coarse fishing is a popular pastime; and it is used for canoes, boats and more recently, paddleboards, with the appropriate licences.

Buffalo Bill

On Bank Holiday Monday, 3 August 1903, the legendary Col W. F. Cody, or 'Buffalo Bill' as he was better known, brought his Wild West Show to the Poor Grounds – now Victoria Park. It was his last tour before retiring.

Thousands of people enjoyed displays of horsemanship, shooting prowess and the famous Rough Riders of the World. It must have been quite a spectacular sight. According to the *Taunton Courier*: 'Not within living memory has there been seen such a crowd in one day at Taunton.' It went on to report that:

> from early morn to mid-day there was quite a stream of vehicles, bicycles, and motors bringing in the country folk from the neighbouring villages, hence it can well be imagined that, with other attractions on that day in the county town, the streets by about 12 o'clock were as full of the public as they could possibly be.

Burma War Memorial

The striking Burma War Memorial stands on a traffic island at the junction of North Street, Hammet Street, and Fore Street.

It is in the style of a tall Celtic cross standing on a stepped plinth, and it commemorates the 144 men of Prince Albert's 2nd Battalion Somersetshire Light Infantry who fell in the Third Burma War of 1885–87. Near the base are carved the additional battle honours of Egypt, Burma, Azim Curh, and Jellalabad.

Originally it was erected at the junction of Fore and East Streets, but following a road improvement scheme the Grade II listed memorial was moved to its present location in 1996. Sitting in the centre of a roundabout, it is a dangerous mission to try and read the dedication and the names of the men who lost their lives, but it is still an eye-catching monument to view from afar.

The Burma War Memorial stands on a traffic island outside the Market House.

The Castle at Taunton Hotel

The Castle at Taunton Hotel was built in the late eighteenth century by Josiah Easton (1767–1845), as a reconstruction of the original Norman castle.

At first, only two floors existed as the plan was for it to mirror Easton's other building across Castle Green, a public house now called The Winchester Arms. At this point, it was a private house, and it wasn't until 1834 that the building became Sweets Hotel. The third and fourth floors were added in the nineteenth century.

The hotel's proximity to the castle site has led to its reputation as one of the most haunted places in the town, with some ghosts said to be connected to the Monmouth Rebellion. This is probably explained by the fact that in 1685 the Duke of Monmouth's officers were heard 'roistering at the Castle Inn' before they were defeated by King James II's men.

By the early twentieth century it was called Clarke's Hotel, before becoming The Castle Hotel in 1928. For the last seventy years the hotel has been owned and run by the Chapman family and is now onto the third generation. As well as being admired for its stunning wisteria display during the spring, the hotel is known for its fine dining and has provided a launching pad for several distinguished chefs, such as the late Gary Rhodes and Phil Vickery. The hotel restaurant held a Michelin star.

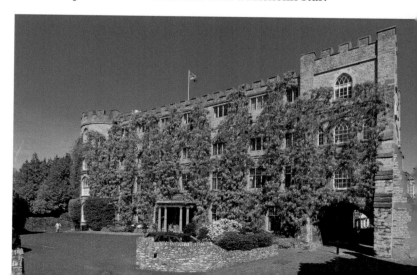

The Castle at Taunton is known for its stunning wisteria. (© The Castle at Taunton)

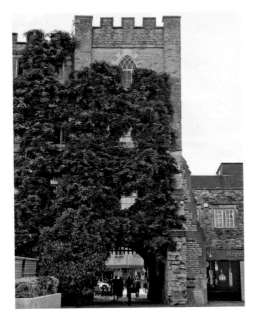

Castle Bow is the remains of the Castle's east gate.

Castle Bow

The Caste at Taunton Hotel restaurant is actually housed in the remains of the castle's original medieval east gate, Castle Bow. This Grade I listed building boasts features dating from the thirteenth century. The gate would have originally been approached over a drawbridge, and a replica portcullis (strong, heavy grating) has been installed in the original grooves inset each side of the gateway.

Castle Green

The Castle Green was the site of an Anglo-Saxon minster church and skeletons that have been excavated have indicated that it was Taunton's burial ground until the twelfth century.

On the building of Taunton Castle in the 1100s, Castle Green was the castle's outer ward and was surrounded by a defensive moat. Access into the Castle Green was via the east gate, the Castle Bow, and a west gate which stood near the current Winchester Arms pub.

The Bishops of Winchester built barns on the green to store produce from their farms. By the 1780s a monthly market was held on the green selling sheep, cows and horses. The livestock market continued to take place here right up until 1929.

Castle Green was re-landscaped in 2012, the year of Queen Elizbeth II's Diamond Jubilee. It now also includes a car park.

Cider Press Garden

Close to Hunts Court and Bath Place resides a small public garden, the Cider Press Garden. The name comes from an old stone and timber cider press dating from the seventeenth century that was gifted to the town by the Taunton Cider Company in 1971 in celebration of the company's Golden Jubilee. This cider press tells a story about a homegrown success, which started over two centuries ago.

In 1805, a group of farmers came together to form a co-operative to make cider in a village just outside of Taunton. This business, based out of Norton Fitzwarren, supplied the town and local villages for almost a century. In the early twentieth century Revd Cornish, a local churchman who was already producing his own cider from locally grown apples, combined his talents with the gardener at his rectory, Arthur Moore, and the co-operative of farmers to form the Taunton Cider Company. They continuously produced non-sparkling cider in traditional wooden barrels up until the Second World War.

Following the war, the scale and range of the business increased quite significantly; the introduction of pasteurisation lengthened the shelf life of their cider considerably, so that it could be sold further afield. In addition to this, the Taunton Cider Company

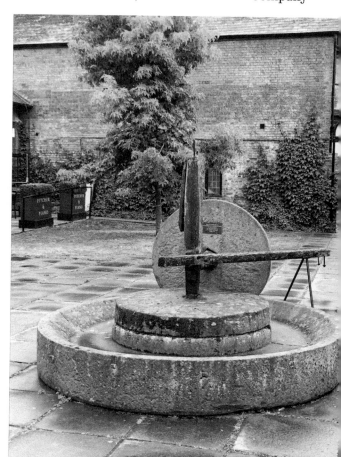

The historic stone cider press commemorating the town's cider industry.

became the go-to for larger companies that were looking to stock cider in the pubs that they had acquired. The result was a huge increase in demand, and as such the mill in Norton Fitzwarren underwent some sizable changes as well.

This growth was boosted by the involvement of Guinness in marketing and strategic decisions, and by the time the company was publicly floated in 1992, it was the second largest cider producer in the United Kingdom, producing 30 million gallons per year and employing almost 550 people.

Sadly this success was not to last, and in 1995 it was purchased by Matthew Clark. They decided to consolidate their cider production at their pre-existing production plant, leading to the eventual closure of the Norton Fitzwarren site in 1998, with a vast majority of the original workforce losing their jobs. Although the plant is now closed the workers' loyalty to, and pride in, their cider company is celebrated and recognised in the Cider Press that graces this small public garden.

County Hotel

Waterstone's bookshop stands on the original site of the Three Cups hotel, built in 1528. In 1909 this rather grand building was owned by Mr E. H. Claridge, who changed its name to Claridge's London Hotel.

The hotel ballroom was first known as the London Hotel Assembly Room. It 1909 it was converted into the Empire Cinema and was used for showing early cinema films. The hotel was taken over by Trust Houses Ltd in 1919 and it was renamed

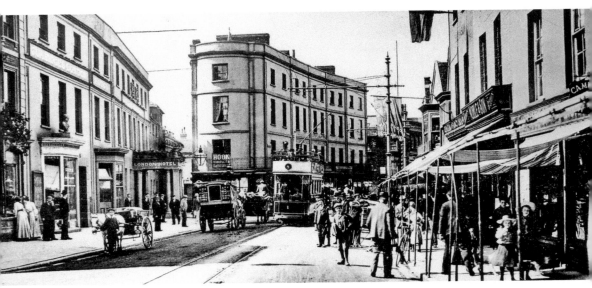

An electric tram in East Street showing Claridges London Hotel on the left, before it became the County Hotel *c.* 1902. (© Electrical Historical Society)

The County Hotel along with the newly named County Cinema. A British Talking Pictures sound system was installed in 1929 but the cinema eventually closed in 1934, following the arrival of the purpose-built Gaumont Palace Theatre which opened on Corporation Street.

The County Hotel put the room to use as the County Ballroom. It became a popular venue with room for 500 dancers. It also had a small stage, and in the 1970s, it was used by performers when they were visiting Taunton. Notable names include Queen, 10CC, Sparks and even the heavy rock band Judas Priest. The County Hotel then went on to become a popular pub along with the sixty-six hotel rooms it provided.

On 8 May 1987, HRH Queen Elizabeth and Prince Philip visited The County Hotel for lunch, during a whirlwind day trip to Taunton. The luncheon menu was reported in the *Somerset County Gazette* as:

Smoked salmon with avocado mousse
Roast fillet of British beef with mushroom-stuffed tomato, spring carrots, mange touts and minted new potatoes
Whortleberry and apple sponge pancakes
Coffee and chocolates
Wines were Muscadet Cuvee Nadelaine Sevre et Maine 1985/6
Chateau Val Joanais Cotes du Luberon 1985

Just seven years later, on 8 January 1995, The County Hotel served its final breakfast for guests before closing. A major refurbishment of the site was undertaken, and it reopened as a shopping mall with six retail units, include Waterstone's.

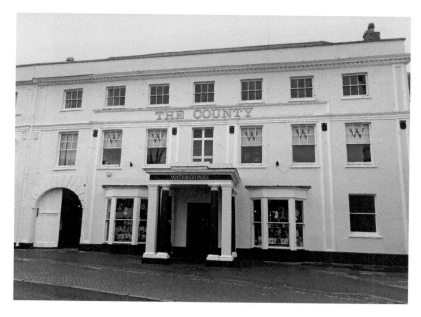

The County Hotel now houses Waterstone's bookshop.

Daniel Defoe

The famous author provides a portrait of Taunton and its history in his Somerset travelogue that began in Wellington, just south of Taunton. The year was 1720, just one year after he published *Robinson Crusoe*, and it gives a fascinating insight into the town, such as the reference to the successful industry in Taunton, the use of 'pot-walloners' in selecting the town's MPs, and the acknowledgment of Taunton's reputation for dissent:

> I entered the county, as I observed above, by Wellington, where we had the entertainment of the beggars; from whence we came to Taunton, vulgarly called Taunton Dean upon the River Ton; this is a large, wealthy, and exceedingly populous, town: One of the chief manufacturers of the town told us: that there was at that time so good a trade in the town; that they had then eleven hundred looms going for the weaving of sagathies, du roys, and such kind of stuffs, which are made there; and that which added to the thing very much, was, that not one of those looms wanted work: He further added, that there was not a child in the town, or in the villages round it, of above five years old, but, if it was not neglected by its parents, and untaught, could earn its own bread. This was what I never met with in any place in England, except at Colchester in Essex.
>
> This town chooses two Members of Parliament, and their way of choosing is, by those who they call 'pot-walloners', that is to say, every inhabitant, whether house-keeper or lodger, that dresses their own victuals; to make out which, several inmates, or lodgers, will, sometime before the election, bring out their pots, and make fires in the street, and boil their victuals in the sight of their neighbours, that their votes may not be called in question.
>
> There are two large parish churches in this town, and two or three meeting-houses, whereof one, is said to be the largest in the county. The inhabitants have been noted for the number of Dissenters; for among them it was always counted a seminary of such: They suffered deeply in the Duke of Monmouth's Rebellion, but paid King James home for the cruelty exercised by Jeffries among them; for when the

Prince of Orange arrived, the whole town ran in to him, with so universal a joy, that, 'twas thought, if he had wanted it, he might have raised a little army there, and in the adjacent part of the country'.

Benjamin Disraeli

In 1835, Benjamin Disraeli, the British statesman and future Prime Minister, unsuccessfully stood for Taunton as the official Conservative candidate.

His extravagant behaviour, debts, and open liaison with Henrietta, wife of Sir Francis Sykes, all gave him a dubious reputation. Incidentally, Henrietta would become immortalised in Disraeli's novel Henrietta Temple published in 1837.

Duke of Monmouth

James Duke of York, the younger brother of Charles II, claimed the throne on the death of Charles. However, James Scott, Duke of Monmouth, was the illegitimate son of Charles II and with the encouragement of others, he was convinced that he was the rightful heir.

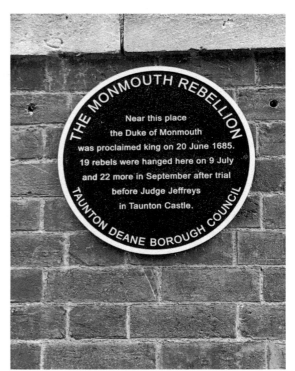

THE MONMOUTH REBELLION

Near this place
the Duke of Monmouth
was proclaimed king on 20 June 1685.
19 rebels were hanged here on 9 July
and 22 more in September after trial
before Judge Jeffreys
in Taunton Castle.

TAUNTON DEANE BOROUGH COUNCIL

A memorial plaque on the Market House in the town centre.

As a result, in 1685 the Duke of Monmouth led a rebellion against King James II. With approximately 6,000 men from the West Country supporting him, he was welcomed by the people of Taunton, and was proclaimed king by the town on 20 June 1685, at the Market Cross on the junction of Fore Street and the High Street (later demolished in 1771).

But his army was poorly disciplined and inadequately armed, many just with pitchforks as weapons, and despite some initial success he was eventually defeated by the King's men at the Battle of Sedgemoor on 5 July 1685.

The Duke of Monmouth fled the battlefield, but his doomed supporters were rounded up and tried in the infamous Bloody Assizes, a court held in the Great Hall in the castle overseen by George Jeffreys (*see* Judge Jeffreys).

The Duke of Monmouth was found a few days later in Hampshire and was executed for treason on 15 July 1685 on Tower Hill in London.

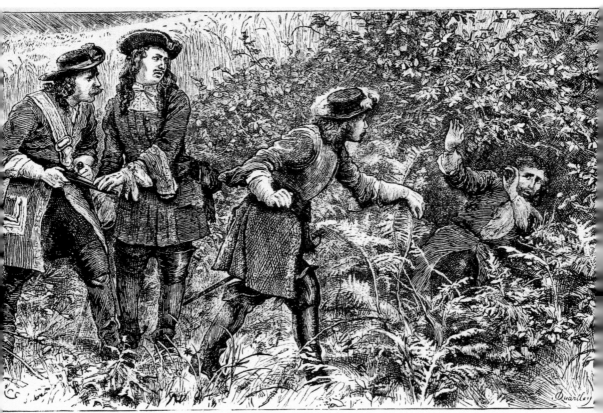

CAPTURE OF MONMOUTH (*see page* 370).

An illustration showing the capture of Monmouth, from the 1873 book *British Battles on Land and Sea*.

E

Electric Street Lighting

By 1878, the streets of London were lit by the first electrical arc lamps, and the ensuing Electric Lighting Act of 1882 was passed to help facilitate and regulate the early electricity industry in the UK.

Taunton became the first town in the South West to have its streets permanently lit by electricity on 1 May 1886. Seven arc lamps initially illuminated the Parade, North Street, High Street, and Fore Street.

All this was down to Henry Massingham, owner of a chain of 'Boot & Shoe Shops' in Taunton. He had attended a display of this new method of lighting at Bristol Cathedral in 1878 and was completely converted to the idea of it and its potential. Fired with enthusiasm, he hired the generating equipment to perform his own demonstration of electric lighting in his hometown. It was a success, and as a result, he founded The Taunton Electric Light Company, licensed through The Board of Trade.

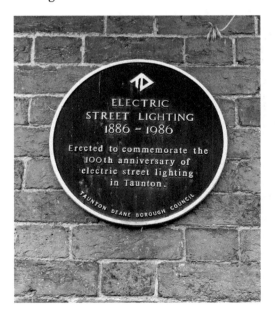

A commemorative plaque on the Market House in the town centre.

The company provided the town with public street lighting from May 1886, with the first private customer, The Castle Hotel, signing up in 1887. His success was largely aided by two other local businessmen: Henry Newton, who owned an electrical manufacturing firm; and Mr. Easton of Easton & Waldegrave, maker of steam engines.

He was not so successful with Bristol City Council, but he managed to establish public electricity supplies in Bath in 1888 and Exeter in 1889. His hard work and commitment came at a high personal cost, however, and by 1901 he was bankrupt and suffering ill health. But a resilient man, he went on to give lectures on the electricity industry and his own vision for its future.

A reproduction of an original 1886 arc lamp post and lantern was installed in front of the Market House together with a heritage plaque to mark the centenary of street lighting in 1986. The replica lamp has subsequently been moved to its current site in Goodlands Gardens.

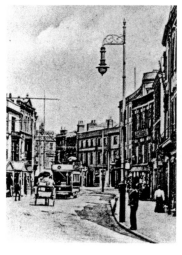

An original electric arc lamp in Taunton c. 1902. (© Electrical Historical Society)

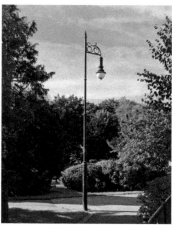

An electric arc lamp replica situated in Goodland Gardens.

Firepool Pumping Station

The Firepool Pumping Station is a Grade II listed, early Victorian structure. It was built on the foundations of some medieval limekilns and sits at the point where the Bridgewater and Taunton Canal, the Grand Union Canal and the River Tone meet.

It was built following the arrival of the British and Exeter Railway in 1842. The role of this historic building was to pump water from the river system into the large water tank, which would subsequently fill the tanks of the steam trains. There is a hot air engine house which was built in around 1866 and in 1877 a wrought-iron water tank was designed, with a capacity to hold 63,400 gallons of water. Its use as a pumping station continued until the 1960s when the onslaught of diesel power rendered it obsolete.

Now deserted, except for a pigeon or two, this rather foreboding-looking building is at the centre of a potential redevelopment plan which includes homes, a hotel and a restaurant.

The pumping station had an important role to play with the arrival of the railway.

Flower Show

For the first weekend in August in Vivary Park, Taunton hosts what the longest-running flower show in Britain, and the second oldest in the world.

The Taunton Flower Show was first held in the Assembly Rooms in the Market House in 1831. Twenty years later, Mr William Kinglake, who lived in Wilton House, offered his private grounds for the show (his estate eventually became the public Vivary Park).

Horticulture is at the heart of the show and the competition and floral class marquees takes centre stage. There are now approximately 250 different classes for amateur gardeners. These stretch back to the early days of the festival when 'cottagers classes' encouraged everyone to enter their produce, flowers and honey.

There are now lots of other attractions to enjoy, including show-gardens built by professional garden designers, craft displays, dog displays, marching bands, a children's zone, and a bee and honey show. Having been referred to as 'the Chelsea of the West', approximately 17,000 visitors now attend over the two-day period.

Only exceptional circumstances have prevented the show from going ahead. It was disrupted by the Second World War, torrential rain was the cause of a last-minute cancellation in 1997, and the Covid-19 pandemic brought about another cancellation. A scaled-down version took place on Castle Green in 2021, and it returned to its rightful home in Vivary Park in 2022.

The Flower Show draws visitors from far and wide. (© Kieran Hanlon)

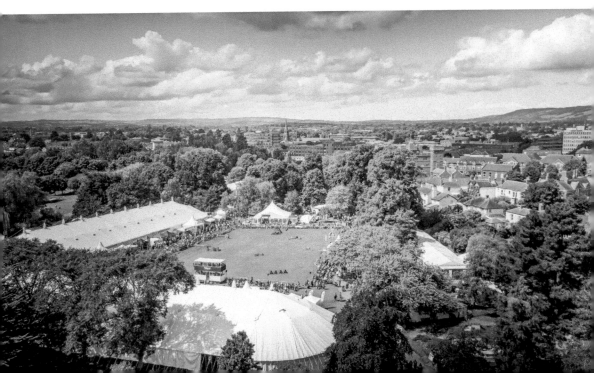

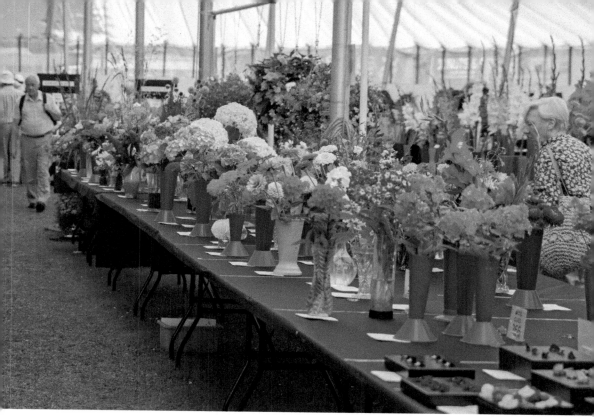

The competition marquees are a key element of the show. (© Tina Downham)

15 Fore Street

15 Fore Street, also known locally as The Tudor Tavern and the Ancient House, is thought to be one of the oldest surviving domestic buildings in Taunton and is now Grade I listed. The three-storey, timber-fronted building has a late medieval hall and open trussed roof. There is even evidence of a blocked tunnel in the cellar.

As you would expect from such an old building, it has a varied history. Now a bustling Caffè Nero, it is just a few doors away from the Market House on a street that would have originally overlooked the medieval marketplace. It was acquired by the Portman family in the fifteenth century and during the sixteenth century it was a clothier owned by Thomas and Joan Trowbridge. They created the striking black-and-white timber frame in 1578, and their initials can still be seen above the door.

In the seventeenth century the building was owned by wealthy grocer, Thomas Baker, who officially welcomed the Duke of Monmouth to the town in 1685. It remained a grocery business principally under the ownership of three generations of the Turle family until it was taken over by an antique dealership, Halliday & Sons. In 1946, after the Second World War, it became a pub, The Tudor Tavern. Restoration on the building was carried out in 2003 at a cost of £200,000.

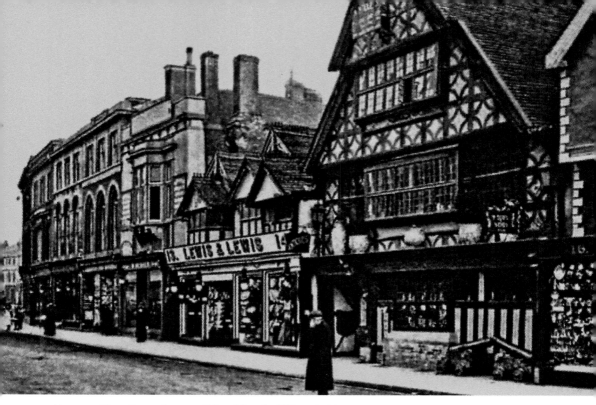

Above: 15 Fore Street is one of the oldest buildings in Taunton.

Below left: The initials of the previous owners from 1578 are still clearly visible over the door.

Below right: A painting of 15 Fore Street. (© Aidan Sakakini)

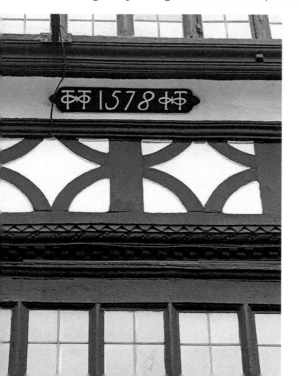

French Weir

The weir was built on the River Tone in the early thirteenth century. Over the centuries it has been destroyed by flooding many times and subsequently rebuilt. Damage was not always a result of natural causes: in 1793 the weir was destroyed by a group of women who believed flour was being sold outside of the town despite severe food shortages.

By the early nineteenth century the river around French Weir was popular for bathing and in 1862 a specific bathing station was constructed below the weir, complete with wooden changing cabins and a concrete waterfront. The first annual swimming and diving competition took place in 1864, creating a stir as the all-male competitors were naked.

French Weir Park was established in 1893 when it was bought by the council. Changes were made in the 1920s: the bathing station was moved above the weir, rather than below it, two diving boards were installed and grab chains were fixed along the riverbank for swimmers. Bathing at French Weir declined with the opening of public baths in 1928 in St James Street, considered a safe alternative to bathing in the river, although now redeveloped for residential use.

However, French Weir remains a well-used small community park, complete with a café and plenty of water sports on offer through the Centre for Outdoor Activity & Community Hub (or COACH).

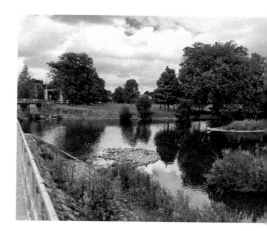

A park has been developed around French Weir.

The public baths in St James Street closed in 2016 for a residential development.

Gaumont Palace Theatre

The former Gaumont Palace Theatre stands on Corporation Street. It was one of the Gaumont-British Picture Corporation's new cinemas sweeping across the country and was opened in 1932 by the Mayor, Councillor W. E. Maynard JP. In recognition of the importance of the occasion, he was accompanied by the musical star of the day, Jessie Matthews. The first film to be shown was the British musical comedy *Sunshine Susie*.

The Grade II listed building is a typical art deco style designed by the architect William T Benslyn from Birmingham. He was also responsible for the Gaumont Palace in Chester, Birmingham and Staffordshire. Over the centre first-floor window on the exterior, a sculptured panel depicting 'Love and Life Entangled in Film' is still visible. This relief was by the English sculptor Newbury A. Trent, who created many of the embellishments on Gaumont buildings.

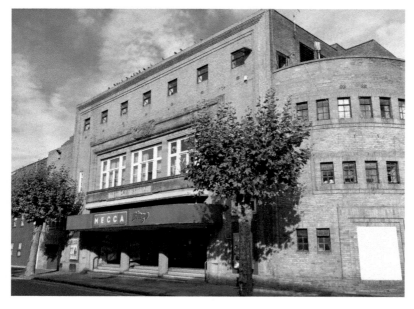

The art deco exterior of the former Gaumont Palace Theatre.

But it's the interior that is really breathtaking: the auditorium and foyer remain largely intact and are elaborately decorated, providing a glimpse of the glamour and colour that would have befitted the golden age of cinema.

With a small stage, the Gaumont was used as a live music venue in its latter years. The Beatles, The Rolling Stones and David Bowie were amongst the artists who performed there. It was renamed the Odeon in 1969, eventually converting to a bingo hall in November 1981. It is now a Mecca Bingo club.

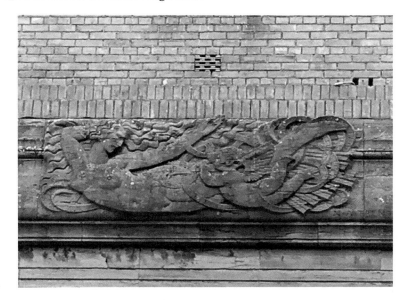

The sculptured panel depicting 'Love and Life Entangled in Film'.

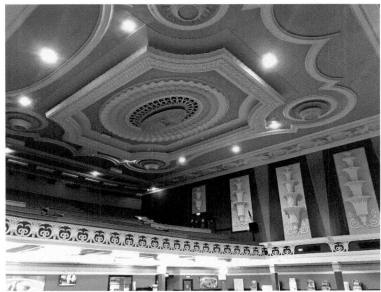

The stunning, colourful auditorium ceiling still creates an impact.

Goodland Gardens

This quiet, tranquil area behind the castle and next to the River Tone deceptively has its roots in the town's industrial heritage. Tone Bridge stands to one side and a mill stream flows through the gardens from its beginnings at French Weir.

The gardens were laid out in 1971 on the site of the town's original fulling mill which dates back to 1219 (fulling was a step in woollen clothmaking which involved pounding it with water to clean and thicken the cloth), along with corn and malt mills. By the 1800s the site was dominated by the Town Mill and the Town Brewery, both of which continued to operate until their demise in the late 1950s.

The gardens were named after a prominent Taunton family. Many Goodland ancestors had worked on the River Tone, including coal merchants from the 1830s who brought coal to the town along the river. Significant members of the family were former Mayor of Taunton William Goodland (1844–1926), Edward Stanley Goodland who also played county cricket for Somerset in 1908 and 1909, and Colonel Herbert Thomas Goodland CBE DSO who became deputy controller of the Commonwealth War Graves Commission 1919–28.

The gardens were re-landscaped in 2012, in celebration of Queen Elizabeth II's Diamond Jubilee.

The river and its streams once powered the town's mills on this site.

Goodland Gardens with a glimpse of
the castle in the background.

Great Western Hotel

In 1842, the first steam trains had begun to puff their way into Taunton station.

Early railway stations provided the first impression that visitors would have of the town, and they were built to impress. Likewise, the closely associated railway hotels that were offering refreshments or a bed for the night. The Great Western Hotel, opposite Taunton's station, was no different, designed in a classical Georgian style and now Grade II listed.

Following its glory days, the hotel was eventually turned into office space in the 1950s before standing empty for several years. But in 2018, a new lease of life was breathed into the building when it was bought by the YMCA Dulverton Group as a social enterprise, to become part of the community. A major renovation was undertaken, and the restored hotel now provides fifteen double rooms, a licensed café and sandwich bar, conference and meeting rooms and work hubs and office space.

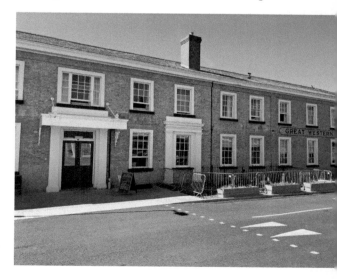

The Great Western Hotel, next to the
railway station, is a community hub.

Sir Benjamin Hammet

Sir Benjamin Hammet was born in Taunton in 1736. He lived in Wilton House in the grounds of Vivary Park on his marriage to Louisa Esdaile, daughter of banker Sir James Esdaile who served as Lord Mayor of London in 1777.

Sir Hammet came from humble beginnings, born to the son of a barber. He rose to fame and fortune, acquiring his wealth through merchant banking and as a building developer. He put this profession to use in his native town, buying and beginning to restore the castle in 1786, and purchasing Bath Place in 1791.

A very visible link with the town is Hammet Street, a short, elegant road which runs from the town centre by the Burma Memorial down towards the Church of St Mary Magdalene. It was developed in 1788 following an Act of Parliament which gave Sir Hammet permission to build his new street. The preamble to the Act stated that it 'will not only be of great benefit and convenience to the inhabitants of the said town, but will also open a view of the ancient and elegant tower, called Saint Mary

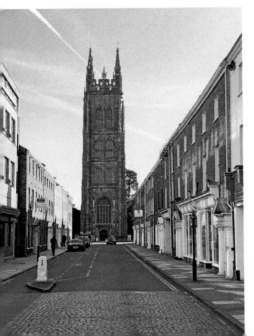

Hammet Street provides a striking view of St Mary Magdalene Church.

Magdalene Tower, and be a great ornament to the said town'. The street cleared the slums and opened up the view of the church.

Hammet was a controversial and divisive character. He held several positions of office, becoming an MP for Taunton from 1782 until his death in 1800 and as Alderman of London. He was knighted in 1786 by George III. A supporter of Pitt's parliamentary reform proposals, one of his greatest achievements was his part in the abolition of the burning of women in England through the Treason Act 1790. In 1797, when he was living in Wales, he was asked to go to London to take the position of Lord Mayor. He refused, citing ill health, and was fined £1,000.

Sir Benjamin Hammet's drive and ambition had overcome his lowly start and his obituary in *The Gentleman's Magazine* described him as 'a conspicuous example of the effects of enterprise and industry'.

Hestercombe House and Gardens

I'm taking a little artistic licence by including Hestercombe House and Gardens as it is situated just over 3 miles outside the borough of Taunton, but with its influence on the area, it would seem wrong to omit it.

The estate dates to the eleventh century when it was owned by Glastonbury Abbey. The earliest medieval feature of the estate still in existence is a stone archway which dates to around 1280. The Warre family purchased the estate in the early 1300s and it remained in their possession for over 500 years.

The house underwent major makeovers through the years. Between 1725 and 1730 the son-in-law of Sir Francis Warre, John Bampfylde, took down most of the medieval part of the house and created the typical Georgian façade that is seen today. In 1872 Hestercombe was bought by the 1st Viscount Portman who gutted the interior of the house and gave it an expensive Victorian makeover. Further modifications continued according to the fashions of the day.

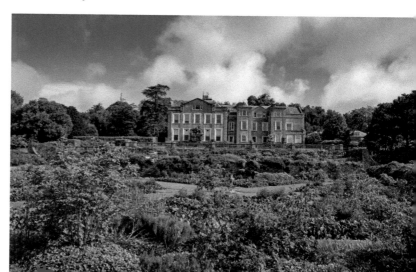

Hestercombe House.
(© Chris Lacey)

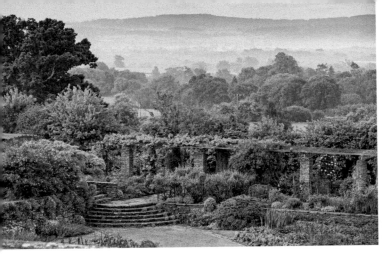

Hestercombe Gardens.
(© Chris Lacey)

After the death of Mrs Portman in 1951, the house became the headquarters of Somerset Fire Brigade for over sixty years. In 2013 the house was bought by the Hestercombe Gardens Trust from Somerset County Council for £1 through the Community Asset Transfer Scheme. It was opened to the public for the first time in May 2014 and now houses a gallery, gift shop and a second-hand bookshop.

The gardens are just as fascinating, featuring different centuries of garden design. During the mid-eighteenth century, a 40-acre Georgian Landscaped Garden was created by John Bampfylde's son, Coplestone Warre Bampfylde. Lord Portman created a Victorian Terrace and shrubbery and in 1904, the Edwardian Formal Garden was the result of a collaboration between architect Sir Edwin Lutyens and garden designer Gertrude Jekyll. A stunning garden which incorporates cobbles, tiles and local stone in addition to the planting, it is considered to be one of the finest examples of their work.

Richard Huish

Richard Huish was a Taunton wool merchant who made his fortune investing in property in London. His will, when he died in 1615, provided the main part of the endowment for an educational foundation to be established.

This eventually led to the formation of Huish's Grammar School for Boys and Bishop Fox's School for Girls. The old Grammar School was built in 1892 at the back of Gray's Almshouses on East Street. Having outgrown the space, the building was demolished in 1972 (it is now Sainsbury's car park) and a new school was built in South Road, now the Richard Huish Sixth Form College.

His will in 1615 also included an endowment to establish an almshouse (or hospital) in Taunton, originally for thirteen men. Still providing accommodation for those in need, the almshouses on Magdalene Street are overseen by the Taunton Heritage Trust.

A memorial stone in St Mary Magdalene Church pays tribute to this prominent Taunton figure.

The Richard Huish memorial stone in St Mary Magdalene Church.

Hunts Court

In 1856 the School of Art, which later became the School of Science and Art, was housed in the Mechanics' Institute in Bath Place. In 1905 it moved into Hunts Court, on Corporation Street. This Grade II listed building, with its imposing neoclassical front and striking frieze, was designed by Samson and Cottam, and was purpose built for the newly named Somerset College of Arts.

When the art school closed it was hoped that the building would retain its association with art and culture. However, this was not to be and it has subsequently been divided in two: one half redeveloped as flats, the other houses the Cosy Club which opened in 2020. Hunts Court provided the first site for this restaurant chain which generally favours iconic listed buildings, with large theatrical interiors.

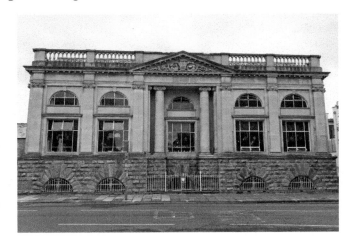

Hunt's Court on Corporation Street has a striking neoclassical front.

Industry

Set in countryside rich in pasture, agriculture was historically Taunton's main industry. By the tenth century it had grown into a small town and was given a charter in 904, granting the townspeople certain rights. A mint was also established, which indicates there was a need to manufacture currency, and a market was held on The Parade – all signs of a prosperous town.

The importance of the River Tone for the town's industrial prowess cannot be underestimated. At the time of the Domesday Book in 1086 there were three watermills, one of which, the town mill, stood on the riverside site of the current Goodland Gardens.

By the 1100s the town was flourishing, becoming known for its wool industry established in conjunction with local sheep farming. As a result of the popularity of the wool, or Taunton's serge, fulling mills were built which provided a way of cleaning the cloth by utilising the power of water. In the fifteenth century the wool began to be exported, first to France, then over the coming century it went as far afield as Africa. According to Joshua Toulmin's history, in the seventeenth century Taunton serge was: 'in very great request as 'fashionable wearing', being lighter than cloth, and yet thicker than many other stuffs'.

Despite this report, Taunton's wool industry was hit by the growth of the Irish cloth industry and competition from the mechanised northern mills. It was to be replaced by the manufacture of silk in the late eighteenth century. Toulmin reported:

> The number of looms employed amounts to about eight hundred in Taunton, and two hundred in the vicinity. There are about one thousand persons engaged in weaving, one hundred as winders and two hundred quillers. The throwing mills employ about five hundred persons; making the whole, about one thousand eight hundred persons.

Silk Mills Road is a nod to the importance of this industry along with a former silk factory built in Tancred Street in 1816 for James Pearsall & Co. Ltd, famous for its silk embroidery yarns. A beam engine which was used to power machinery at Pearsall's

silk factory until 1955 can now be seen in the museum. Production of its embroidery silk continued well into the twenty-first century.

In 1823, it was noted that 800 tons of goods were exported from the town by the river alone. But with the arrival of the railway in 1842, combined with the river and the canal, there were plenty of industries that were able to prosper including timber, stone and brick works, foundries and breweries.

Clothing was also a popular, thriving industry and in 1899, the Mayor of Taunton, Henry Joseph Van Trump, built a collar-making factory on St Augustine Street. The company was overseen by three generations of the family until 1964. The building was renovated and in 2022 it opened as a 'state-of-the-art' workspace, called the Collar Factory.

Taunton joined the General Strike of 1926 to support the miners who faced cuts in pay and longer hours. Workers in the town's railway, brick and tile industries walked out in solidarity of the national strike. On a more positive note, Taunton replaced Weston-super-Mare as the county town in 1935, reflecting its growth in size and importance. With the opening of the M5 in 1974, the town became more accessible to the rest of the country and as a result both tourism and retail are currently major industries.

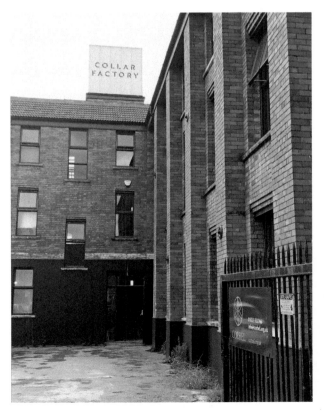

Blending new industry with old, a modern workspace has been opened in this historic shirt and collar factory.

Jellalabad Barracks

Jellalabad Barracks, backing onto Vivary Park, is a striking, unmissable building built in a Gothic Revival style which was inspired by medieval design.

The barracks were opened in Mount Street in 1881 as a base for the Somerset Light Infantry and named after the celebrated Battle of Jellalabad in which the regiment had taken part.

In 1838 the British army, including the Somerset Light Infantry, invaded Afghanistan. The aim was to protect British India in the south from Russia to the north of Afghanistan and one way to do it was to install a new Afghan ruler who would be sympathetic to their interests.

Initially the invasion was a success, until Afghan tribesmen began to fight back resulting in the massacre of the garrison at Kabul in 1842. At the same time as this devastating event, the British regular 13th Light Infantry and the 35th Bengal Native Infantry were besieged in the fortress town of Jellalabad. After many months blockaded in Jellalabad, they eventually broke out and defeated the Afghans in one of the most famous military operations of the Victorian age: approximately 1,500 men took on up to 6,000 Afghans under the command of Brigadier Sir Robert Sale.

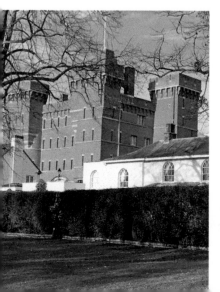

The keep of Jellalabad Barracks is quite a sight when walking round Vivary Park.

Jellalabad Barracks remained the Somerset Light Infantry's depot until the regiment's amalgamation with the Duke of Cornwall's Light Infantry, forming the Somerset and Cornwall Light Infantry in 1959. The barracks were sold for residential development in the early 1990s.

Judge Jeffreys

Although not a citizen of the town, Judge Jeffreys has to be included as he is irrefutably linked with possibly the worst period in Taunton's history, if not all of Somerset. Dozens of people were sentenced to death by the notorious Judge Jeffreys in the Bloody Assizes in 1685. They were accused of high treason for rebelling against King James II in the Monmouth Rebellion.

As a result of a speedy two-day trial held in the castle's Great Hall, over 500 prisoners were tried by Judge Jeffreys. He was so brutal that he became known as the Hanging Judge, sentencing approximately 150 to death by hanging, drawing and quartering. Their remains are said to have been displayed around the county as a warning of what would happen to those who went against the King. The rest of the prisoners were transported to the West Indies to work on the sugar plantations.

George Jeffreys had come from relatively humble beginnings, born in Wales in 1645 during the Civil War. He worked his way up the legal profession, finding favour with King Charles II and later King James II. At the time of the Bloody Assizes he was Lord Chief Justice; three months later he was made Lord Chancellor.

In 1688, when William of Orange invaded England, King James II fled London, followed sometime later by Jeffreys. His disguise as a sailor was unsuccessful and he was caught and taken to the Tower of London. He died in the Tower in April the following year from a rare kidney disease.

George, 1st Baron Jeffreys of Wem (1648–89), by Sir Godfrey Kneller, formerly attributed to John Riley.

King's College

Richard Foxe, Bishop of Winchester, was the founder of Corpus Christie College Oxford University in 1515–16. In later life, he turned his attention to Taunton and built a grammar school within the castle's walls in 1552, although there are references to a school being on the site since the thirteenth century. The building was the east side of what was to become the Municipal Building.

It was decided that the location of the school was not ideal, and certainly not conducive to learning, backing onto barns, stables and a livestock fair. The headmaster was a visionary, the Revd William Tuckwell, and he moved the school to South Road in 1870. As an aside, although girls were not admitted to the school, he believed they should be educated, and he worked to encourage girls to take exams. His daughter, Gertrude, became an activist and an English trade unionist.

The school experienced financial difficulties and returned to Corporation Street in 1880. Five years later it closed completely, but it led to the formation of two new schools which both exist today: King's College on the South Road site and Bishop Fox's School.

King's College founder Canon Nathaniel Woodard was an educational innovator whose philosophy was to combine modern academic teaching with a strong Christian education. Interestingly, the science room at King's College is thought to be the first purpose-built science classroom in any British school, dating from 1873. When Tuckwell designed the school buildings in South Road, he wanted science to be at the centre of the school's curriculum.

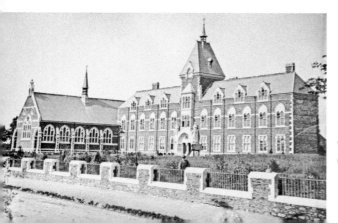

The front of King's College, *c.* 1870.
(© King's College, Taunton)

The South Road site houses the senior school whilst the prep school is in King's Hall, formerly Pyrland Hall on the outskirts of town.

King Ine of Wessex

Taunton was founded in the early eighth century by King Ine of Wessex (also recorded as King Ina or Ini), considered by many to be one of the most successful West Saxon rulers prior to Alfred the Great.

He reigned as King from 689 to 726, during which time he dominated much of the south of England. In approximately 710 he built a stronghold in what would become Taunton, creating an earthen castle for his wife, Queen Æthelburg.

According to the Anglo-Saxon Chronicle (manuscripts in Old English which chronicled the history of that time), Taunton was seized in 722 by a rebellious noble named Ealdbert. King Ine was absent at the time, and so Queen Æthelburg took the defence of Wessex into her own hands, marching to confront Ealdbert at Taunton. Her army destroyed the fortification but Ealdbert escaped and fled to Sussex. He was eventually tracked down and killed by King Ine in 725. In the Anglo-Saxon Chronicle, under the date AD 722, it reads:

'This year Queen Ethelburga overthrew Taunton, which Ina had before built. And Eadbert the exile went away into Surrey and Sussex, and Ina fought against the South Saxons.'

They were obviously quite a couple. Queen Æthelburg was a remarkable woman and King Ine was a successful warrior. He was also one of the first Anglo-Saxon kings to develop a written code of laws, issued in approximately 694. It provides some insight into the way they lived at the time, and also highlights King Ine's religious convictions, as an early Christian ruler. He founded a minster at Wells, which later became the cathedral, and also built a stone church at Glastonbury, which in due course became the abbey.

A stained-glass window depicting King Ine of Wessex can be seen in Wells Cathedral.

Leper Hospital

A deceptively quaint-looking house on Hamilton Road, St Margaret's Almshouse began its life in the early twelfth century as the hospital of the Holy Ghost and St Margaret, a leper hospital. It is thought to have been run by the monks of Taunton Priory and had its own chapel and cemetery.

The disease flourished with human contact and, as the town began to grow, so did the cases of leprosy. Diseased locals were locked away, and the building is said to have secret underground tunnels for the dead to be taken away to a nearby cemetery.

Glastonbury Abbey took over the patronage of the building in the late thirteenth century, and by the fifteenth century the disease had all but died out. It was rebuilt as almshouses in approximately 1510 by Abbot Richard Beere and continued to be used in this way until the late 1930s. It was then converted into offices for the Rural Community Council, remaining in use until the early 1990s when a fire destroyed the thatched roof.

Thankfully the building was subsequently bought by the Somerset Building Preservation Trust with Falcon Rural Housing and restored to be used as social housing in 2003. It is now a Grade II* listed building.

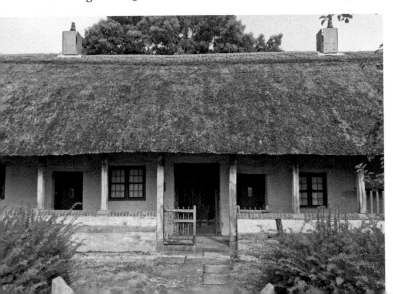

St Margaret's Almshouse began life as a leper hospital.

M

Markets

In 904, Taunton was given a charter and reference is made to a market. It is mentioned again in the Domesday Book in 1086. By the twelfth century the marketplace is acknowledged as the triangular site close to the castle called the Parade, where North Street, East Reach and the High Street meet. By 1321 a market cross was installed, named the High Cross.

By the fourteenth century Taunton was one of the largest and wealthiest towns in the county after Bath and Bristol, and the market reflected this posterity. Market day was busy, bustling and often chaotic, especially with the livestock that were brought into the town including cattle, sheep, pigs and horses. In 1614, a separate pig market was set up on site between High Street and Paul Street where it continued until 1882. It is now the indoor Orchard Shopping Centre, although many people still refer to it as the Pig Market. By the eighteenth century, Castle Green was being utilised as a livestock market for sheep and cattle.

The introduction of motor vehicles in the early twentieth century made holding a livestock market in the centre of town rather precarious and in 1929 it was moved to Priory Bridge Road. Cattle trading continued right up to 2008.

Continuing the tradition that is over a thousand years old, there is a regular weekly farmer's market on the High Street, and a regular monthly independent market has returned to the Castle Green.

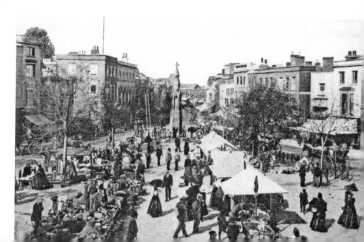

Market day on the Parade.

The Market House

Standing in a commanding position in the town centre, the Market House overlooks the Parade, the site of the old market and a triangular island where North Street, East Reach and the High Street all meet.

The handsome red-brick building was designed in 1772 by Coplestone Warre Bampfylde, the owner of Hestercombe House and a garden designer and amateur architect. It was designed as a multi-purpose building with separate areas for the administration of justice and for amusement: the ground floor served as the Guildhall and an elegant assembly room on the first floor was used for music functions. In 1831 the clock was donated to the town by Henry Labouchere, a Whig MP who later became 1st Baron Taunton.

For almost two centuries the Market House was an important meeting place, with a strategic position overlooking the market. In 1929 the market moved to a different part of town and in 1932 the Market House underwent alterations and two side wings were added. The building now houses a restaurant and the Taunton Visitor Centre.

The Market House.

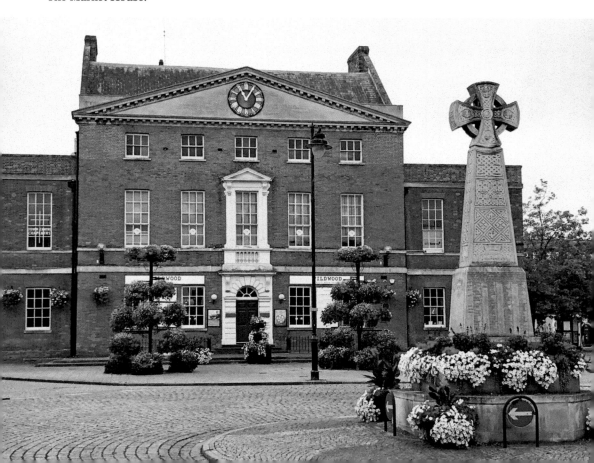

A plaque either side of the main entrance commemorates the building of the Market House.

The Masonic Hall

The Masonic Hall is at the end of a grand Georgian terrace, aptly named The Crescent. It was originally built as St George's Chapel in the early nineteenth century, the first Roman Catholic chapel open for public worship in Taunton since the Reformation. In 1878, it was sold and dedicated as the Masonic Hall in 1879. It took on many uses, including a classroom for Huish's School for Girls (now known as Bishop Fox's), and used as a wine warehouse. The Grade II* listed building is currently home to nine lodges of the Freemasons.

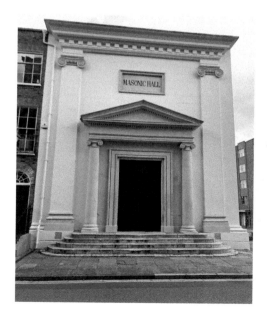

The Masonic Hall began life as St George's Chapel.

The Mayor

In 1627 Taunton was granted a new charter and was given a mayor and a civic corporation. It was also no longer under the rule of the Bishops of Winchester.

Andrew Henley was the first mayor under this charter. However, when Charles II regained the throne in 1660, he annulled Taunton's charter in punishment for the town supporting the Parliamentarian cause in the Civil War. He was later persuaded to renew the charter in 1677.

Alfred Bult Mullett

Alfred Bult Mullett (1834–90) was born in Fore Street in a house which is now occupied by the retailer Jack Wills.

When Mullett was eight years old, his family emigrated to Ohio, America, where his father bought a farm. Having studied architecture, he went on to become one of the nation's leading architects of the time and was the US Gov. Architect to Abraham Lincoln. As such, he designed the Eisenhower Executive Office Building next to the White House in Washington DC.

He was also hired by A. S. Abell, publisher of *The Baltimore Sun*, to design a building to house the paper's Washington news bureau in 1887. It was the first skyscraper in Washington and is viewed as a fine example of the Victorian Gothic style of architecture. Mullett also incorporated steam elevators into his design, making the Sun Building one of the first structures in Washington to use a passenger elevator.

He was obviously quite a controversial character and his career didn't always run smoothly. He was investigated for negligence when three men were killed on 1 May 1877 by a floor failure at the City Hall Post Office, New York City. *The New York Sun* called him 'the most arrogant, pretentious, and preposterous little humbug in the United States'. He came to a tragic end, killing himself in 1890 as a result of financial problems and ill health.

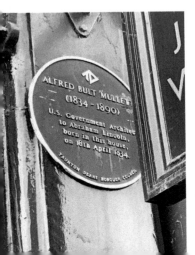

Alfred Bult Mullett's house is now occupied by Jack Wills.

Newspapers

Several newspapers for the town have opened and closed over the years, starting with the *Taunton Journal* which was first published on 21 May 1725. The *Somerset County Gazette*, however, has stood the test of time and still continues today.

The first issue was a four-page broadsheet called *The Somerset County Gazette, Taunton, Bridgwater and Wells Chronicle and North Devon Journal*, published by Edward William Cox on 31 December 1836. He was soon selling 700 copies a week, reaching 1,100 by 1840. In 1843 William Augustus Woodley became editor and later owner of the paper. He moved the printing office from Paul Street to Castle Green.

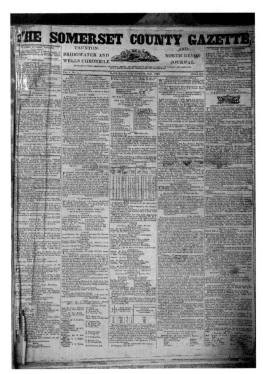

The first edition of the *Somerset County Gazette*, 31 December 1836. (© Somerset County Gazette)

By the paper's 50th anniversary, it had extended to twelve pages and, with mechanisation, had actually come down in price, costing 3*d*. The pages were filled with town items, court reports, farming news, national articles and international news. During the twentieth century the circulation continued to increase. It went to a tabloid size in 1991 and colour photographs were used in the main body of the newspaper in 1997. It is now part of the Newsquest group.

North Street

North Street is in the retail heart of the town, stretching from the River Tone up to the Market House. In fact, highlighting its central position, part of the street is found to have been within the borders of the historical Saxon settlement.

It has been a busy, bustling street throughout the ages and was included in the tramline route during the early twentieth century. Significant buildings on the street include the old Debenhams store which closed in 2021. Prior to being taken over by Debenhams in 1959 it was the Chapmans department store, founded in 1864 by William Chapman and Arthur Chapman. The shop began at 20 North Street and slowly expanded into adjacent buildings to become a large department store selling

North Street *c.* 1902, showing an electric tram. (© Electrical Historical Society)

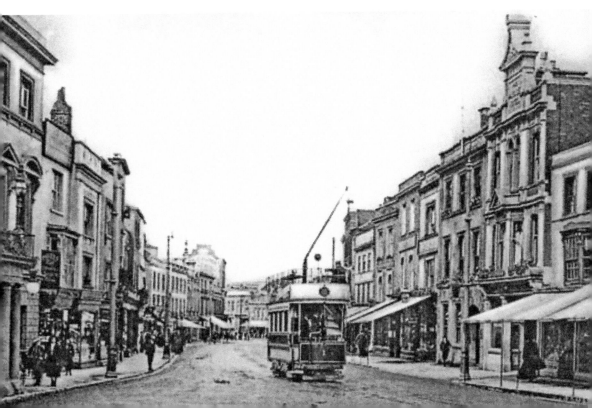

furniture, carpets, drapery and household goods. When Debenhams took over the site there was a substantial remodelling of the building, but it still retains its 1930s art deco frontage.

Other buildings of note are 52 North Street which housed the County Stores, another long-established family-run business which closed in 2018 after 186 years. The Post Office was also located in North Street, first in 1882, before moving to Hammet Street and then returning to North Street in 1911. This time it was on the site of The Spread Eagle Inn at 38 North Street, where it remained for the next hundred years, closing in 2014. The handsome Edwardian red-brick and Portland stone building is now the restaurant Ask Italian, but the wording 'Post Office' above the two doors are still a visible sign of its previous life.

The old Post Office on North Street is now an Ask Italian restaurant.

Old Municipal Buildings

The impressive Grade II listed Old Municipal Buildings stand on Corporation Street with Castle Green and Taunton Castle to its rear.

The east side of the building dates to 1522 when it was constructed as a boys' grammar school, founded by Richard Fox, Bishop of Winchester. Despite being badly damaged during the English Civil War, *c.* 1644, the building was restored and continued to be used as a school until 1885. In the same year it was converted to local government offices for the local borough council. To extend the facilities, the building was extended to the west side (the right-hand side when facing it) at the beginning of the twentieth century – you can see a difference in the stonework.

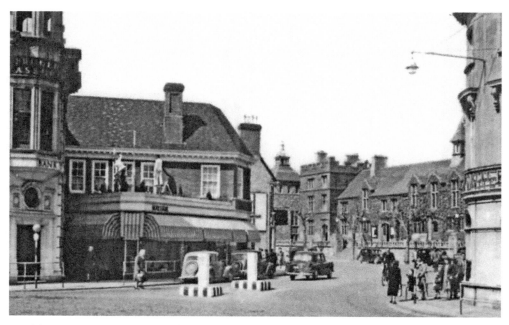

An old photograph of the top of Corporation Street shows the Old Municipal Building on the right-hand side.

The east side of the building is quite distinctive (*on the left*). It housed the boys' grammar school in 1522.

A plaque was unveiled by Her Majesty, Queen Elizabeth II.

It remained the Taunton Corporation headquarters until the spring of 1987 when the office moved to a modern building in Belvedere Road. In the same year on 8 May, the Old Municipal Buildings were included in a royal visit to the town and a plaque was unveiled by Her Majesty Queen Elizabeth II to mark the occasion. Renovations were underway at that point and the building was reopened as a voluntary service centre by Princess Margaret on 12 June 1987. In 2008, it became the home of Somerset Register Office and is now used for marriages and civil partnerships.

Old Public Library

Opposite the Old Municipal Buildings on Corporation Street stands the Old Public Library.

Designed by London architects Alexander Colbourne Little & Ingreson C. Goodson, the Old Public Library was opened in 1905, one of the 660 UK libraries built between 1883 and 1929 that were partly founded by the Carnegie Foundation. This had been set up by the Scottish-American businessman and philanthropist Andrew Carnegie (1835–1919).

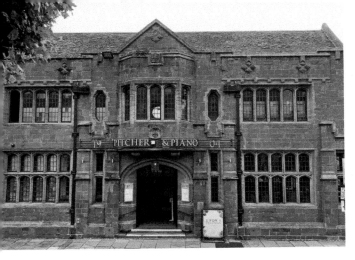

This handsome building is now owned by Pitcher & Piano.

The foundation stone is still visible on the exterior wall of the Old Public Library.

Carnegie believed in the importance of education and self-improvement, and felt books and libraries were integral to this personal advancement. Most of the Carnegie libraries were subject to the 'Carnegie formula', which meant the town involved had to provide some financial and community commitment towards the building in addition to his donation to ensure the library was not taken for granted.

The building was opened by the Mayor of Taunton, Josiah Lewis, in August 1905 and it continued to serve as a library before moving to larger premises in Paul Street in 1996.

The building was subsequently converted to a public house, causing some controversy as one of the conditions outlined by the Carnegie Foundation had been that no alcohol should be consumed on the premises.

Owned by Pitcher & Piano, the building enjoyed a £550,000 refurbishment in 2022 which has retained the historic exterior but has provided a contemporary, modern interior.

Priory Barn

The Taunton Priory, or the Priory of St Peter and St Paul, was an Augustinian house of canons founded in approximately 1120 by William Gyffarde, Bishop of Winchester and Chancellor of England during the reign of King Henry I.

Originally the castle was built next to the priory but then in 1158 it was moved outside of the castle walls. Names such as Priory Avenue and Priory Bridge provide a pretty good clue as to its new location, near St James Church. The priory was dissolved by King Henry VIII in 1539 and everything was destroyed except for the Priory Barn which still survives today. In 2005 archaeologists began an excavation of a site opposite the barn, on the corner of Priory Avenue and Gyffarde Street, carried out before the construction of a block of flats. The dig revealed the location of the Priory Church and cemetery.

The barn has had a variety of uses over the centuries, from a farm barn to providing storage in a builder's yard. The Somerset Cricket Museum bought it in the 1980s and major renovations took place, completed following a major legacy in 2010. It is now Grade II* listed.

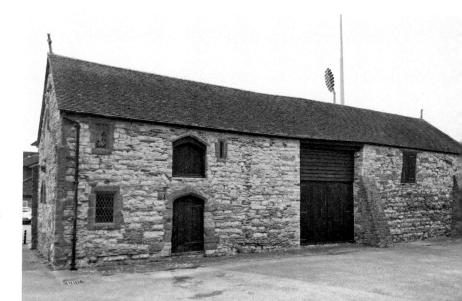

The Priory Barn is all that remains of the Priory.

Quaker Meeting House

The Quakers movement, or the Religious Society of Friends, was founded in England in the seventeenth century during the aftermath of the English Civil War.

Early Quakers preached that there was no need for churches or holy days, at a time when the established church held great political power. As a result, they were often persecuted and had to meet in each other's houses. It was a precarious time; record shows that there were Quakers in prison for refusing to take the oath of allegiance to the Crown and the Church of England.

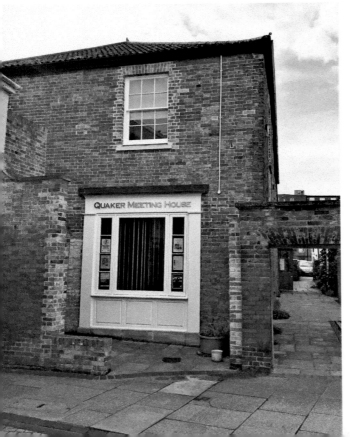

The Quaker Meeting House is at the end of Bath Place.

After the Monmouth Rebellion in 1685 the town was full of soldiers, so not many meetings were held, but the number of Quakers was increasing. By 1693 a large meeting house had been built in Bath Place (or Hunt's Court as it was then), given to the Friends by grocer Robert Button, complete with a burial ground behind the building.

The house was rebuilt in 1816 and has been extended, most recently in 2014. Burials ceased in 1832.

Queen's College

Queen's College was founded in 1843 by local Methodists the Wesleyan Collegiate Institute, and was originally named the West of England Wesleyan Proprietary Grammar School.

The school was originally held in Castle House within the castle grounds. The first head was Thomas Sibley and under his leadership the school soon outgrew the site, moving to its current location on Trull Road in 1846. Its name was changed to Queen's College in 1887 to commemorate Queen Victoria's Golden Jubilee. In 2016, Lorraine Earps became the first female head teacher.

Queen's College on Trull Road was built in 1846.

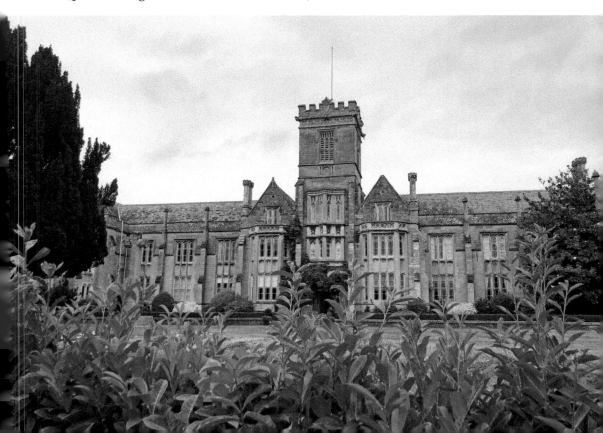

Queen Victoria Memorial Fountain

The ornate fountain in Vivary Park was originally ordered in 1902 from the MacFarlane Foundry, also known as the Saracen Foundry, the most important manufacturer of ornamental ironwork in Scotland. It was paid for with funds left over from the coronation of King Edward VII in the same year. The fountain was finally completed in 1907 and was officially unveiled as a memorial to the late Queen Victoria by the Mayoress on 31 October 1907. A Victorian baroque fountain, it features a female figure surrounded by birds, columns and cherubs both blowing horns and riding fish.

The inscription on the memorial plaque reads:

> *Erected by the people of Taunton in loving memory of her most gracious majesty, Queen Victoria, under a scheme inaugurated by A.E. Perkins, J.P. Mayor and completed 1907, J.P Sibley J.P Mayor.*

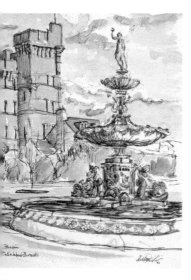

A painting of the Queen Victoria Memorial Fountain of 1907, with the Jellalabad Barracks behind. (© Aidan Sakakini)

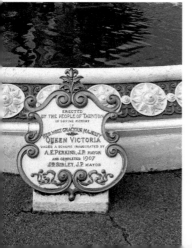

A suitably decorative plaque for the elaborately ornate fountain in Vivary Park.

R

Railway

Taunton railway station was originally opened in 1842 as part of the Bristol and Exeter railway line, providing the first link between Taunton and London. The station was designed by Isambard Kingdom Brunel, the chief engineer for the Great Western Railway, and the original plan was for a single-sided station with two platforms. The station now has six platforms and links the town to London, Cardiff, Bristol, Exeter and Plymouth.

The arrival of the railway played a key role in the town's prosperity during this time; it brought visitors to Taunton and linked its trade to the wider world. On 27 March 1862, the West Somerset Railway branch line opened between Taunton and the seaside port of Watchet, then extending to Minehead in 1874. It was closed in 1971 but reopened five years later as a heritage railway – in fact, England's longest heritage railway. It no longer stops at Taunton except for specially organised trips.

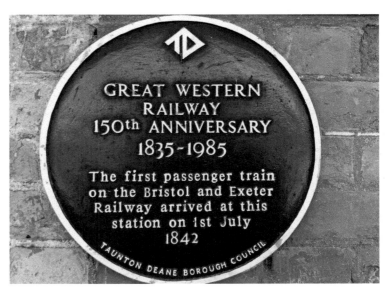

The plaque commemorating the 150th anniversary of the Great Western Railway in 1985 is on the wall of Platform Two.

River Tone

The River Tone flows for 33 km from Beverton Pond in the Brendon Hills before flowing into the River Parrett at Burrowbridge, and continuing out to the Bristol Channel through Bridgwater. Along its journey, it flows through the centre of Taunton and as such, it was important for the town's industrial development. It was an important waterway for transporting goods, it powered mills along the banks and was also a fishery.

In 1638 John Mallett, the Sheriff of Somerset, obtained a commission under 'the Great Seal from King Charles I', which granted him and his heirs sole navigation rights from Bridgwater to Ham Mills. As a result he took it upon himself to pay for improvements to make the river navigable and improve the transport infrastructure.

When both he and his son had died there was no one to continue the upkeep of the river and its condition began to decline, ultimately impacting trade. In 1699, an Act of Parliament created the Conservators of the River Tone, giving a group of thirty-four men powers 'for making and keeping the River Tone navigable from Bridgewater to Taunton, in the county of Somerset'. This included building bridges, locks, a path along the side and to charge tolls. A condition of this agreement was that profits should be used to benefit the poor of Taunton although this didn't happen until 1843 when the Conservators funded a wing of the Taunton and Somerset Hospital, and invested in the Taunton Market Trust.

The job of the Conservators became more complicated in 1827 when the Bridgwater and Taunton Canal opened, meeting the River Tone at Firepool weir. The canal provided a more direct route between Taunton and Bridgwater which impacted negatively on the river trade. A tricky time lay ahead and in 1832 an Act of Parliament authorised the canal company to take over the river and water rights. Navigation rights were repealed in 1967.

A plaque near the Tone Bridge marks the location where the Conservators were based. It states:

> 1699-1969, Conservators of the River Tone. Near this spot were the steps and landing place of the Conservators of the River Tone. From 1699-1839 the Conservators kept the river navigable between Taunton and Bridgwater. From 1839-1969 they had a statutory duty to inspect annually the Bridgwater and Taunton Canal and the section of the river through the town.

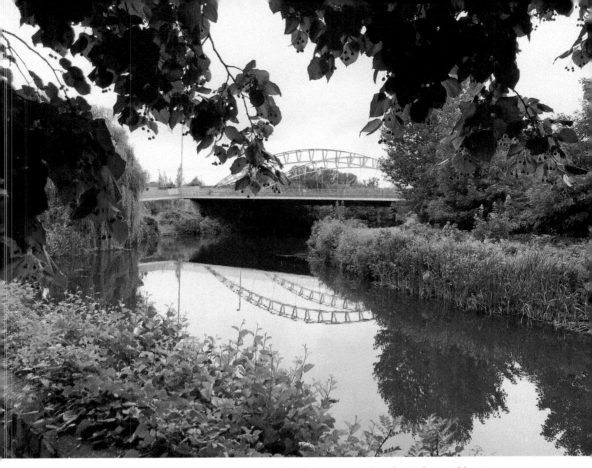

Running through the town, the River Tone has been integral to the industrial heritage of Taunton.

St James Church

Overlooking Somerset County Cricket Ground is the tower of St James Church, one of Taunton's most significant churches and a beloved skyline feature for cricket spectators.

It dates from the early fourteenth century, although it is believed to be on the site of a twelfth-century church which was associated with Taunton Priory, built for those who lived outside the town's castle defences.

The church is full of interesting historical pieces. The font, which dates from the fifteenth century, is notable as one of the most adorned in the country, featuring carvings of the twelve disciples with Jesus. The beautifully carved pulpit opposite the font is from the seventeenth century and unusually, is decorated with a frieze of mermaids and suns. The majority of the stained-glass windows date from the nineteenth century, but one in particular was of interest: the Children's Window installed in the 1950s, donated by John and Jessie Spiller in grateful thanks for the return of eleven nephews from the Second World War.

Like many of the churches in Taunton, St James underwent significant reconfiguring in the nineteenth century which included the 120-foot-high tower being demolished and rebuilt. Look carefully and you can see it is a different stone to the rest of the church.

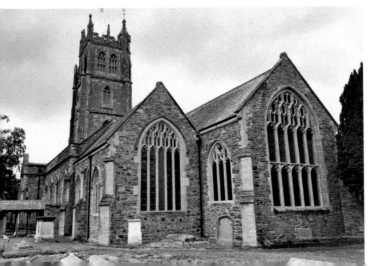

The new tower built in 1871 is made from red sandstone, a slightly different stone to the remainder of the church building.

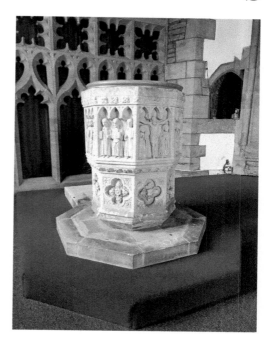

The beautifully carved octagonal font dates from the fifteenth century.

St Mary Magdalene Church

Amongst the most beloved of the historical buildings in Taunton is the church of St Mary Magdalene, situated in the town centre, at the end of Hammet Street.

Established in the twelfth century as part of the reorganisation of Taunton by Henry of Blois, it became the town church in 1308. Elements of the north aisle date from this original church, including two pink-stoned pillars.

Other striking features of the church include the sixteenth-century ceiling decorated with gilded angels and coats of arms. The nave is also unusual in that it has double aisles and is divided into five sections – it is one of only five such naves in England.

In the early sixteenth century, the prosperity generated by the local wool industry enabled the church to double in size and resulted in the creation of a magnificent tower which stands at almost 163 feet tall, making it the tallest church tower in Somerset. The tower was then rebuilt to the original designs in 1862.

The views offered from the top are extraordinary and have been enjoyed by some surprising characters; a pulley system, powered by a donkey walking down Hammet Street, was used to lift the stone during the reconstruction, and when the project was finished, the donkey was lifted to the top to look down on Somerset from the tower it had helped to build. The tower housed the town's first fire engine in 1734, and currently is home to a pair of peregrine falcons.

In 2022, St Mary Magdalene Church was officially confirmed as Taunton Minster, a title that is bestowed on major churches of regional significance.

An original pillar in St Mary Magdalene Church dates from 1308.

The stunning, elaborately painted ceiling, complete with gilded angels.

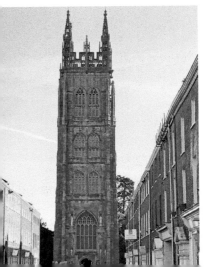

Look out for tours that enable you to climb the tallest church tower in Somerset.

Joseph Sewell

The Museum of Somerset has a pair of Joseph Sewell's shoes on display. Born in Lincolnshire in 1805, Sewell was abnormally large from a young age: by the time of his death in 1829, he was 7 feet and 4 inches tall, and weighed 37 stone.

Putting his size to use as a way to make his living, he toured the country displayed as a curiosity. However, on his travels in approximately 1826 he became ill with typhus fever which not only made him feeble and weak, but tragically caused him to lose his eyesight. After recovering enough to continue travelling, he had the good fortune of making his way to Taunton and Exeter where the people gave him a warm welcome and took pity on him. Funds were raised to purchase Sewell a caravan and provide an assistant, James Bromsgrove, to help him with his touring.

In 1829 in Swansea, Sewell fell gravely ill again and this time he succumbed to the disease at just twenty-four years of age. According to the edition of *The Monmouthshire Merlin* printed on 11 July 1829:

> He arrived on Wednesday and exhibited the whole of Thursday (fair day) with a midget called Farnham.
>
> Friday evening he complained of being unwell and shortly afterwards had several epileptic fits, which so completely shook the caravan, that the men were obliged to secure the wheels to prevent it from falling.
>
> Some medical men were immediately sent for, but it was evident to them that he could not survive long, and he expired about 12 o'clock on Saturday night.

With a fear of grave snatchers, not uncommon for that time, he had already made a request for his corpse to come back to Taunton for burial as he felt sure it would be treated with respect. He was right; the people of the town gave him a spectacular funeral with the expenses covered by a local tradesman, John Bluett. Sewell was laid to rest, in an elm coffin almost 8-feet long in the churchyard of St Mary Magdalene Church. Although its location is no longer known.

Shire Hall

In the mid-nineteenth century, it was decided that the Great Hall of Taunton Castle was no longer in an adequate state to be the location for the county assizes. To meet the need for a place to hold court, the Gothic-style Shire Hall was designed in 1858 by William Bonython Moffatt, who also designed the Taunton and Somerset Hospital on East Reach, and built by a local contractor, George Pollard.

Following the introduction of the Local Government Act in 1888, Shire Hall became the meeting place of the Somerset County Council, whilst still keeping its function

as a place for the distribution of justice. In 1935, the County Council moved to its new location at County Hall and the former Shire Hall was once again used only as a Crown Court.

Somerset County Cricket Ground

The County Cricket Ground is home to two successful cricket teams: the England Women's Cricket Team, and the Somerset County team, who for the last decade have been amongst the top first-class county teams in the country, finishing second in Division One of the County Championship in 2012 and 2016. There are stands that can hold 8,500 people and with the ground also being used for male international matches, there is no shortage of action to watch.

The Ground was originally home to Taunton Athletic Club, established in 1829. Somerset County Cricket Club was first formed in August 1875, following a cricket match at Sidmouth between the 'Gentlemen of Somerset and their Devon hosts'. They were a nomadic club for a few years then played their first game at the Ground in 1882 and finally bought it in 1896 to make it their permanent home. The first international action seen at the Ground took place in 1983 when it hosted a match between England and Sri Lanka in the World Cup, and it has been home to the England Women's team since 2006.

Some of the all-time great cricketers have played here including Sir Ian Botham, Sir Viv Richards, Joel Garner, Steve Waugh and Martin Crowe. Marcus Trescothick made his debut for Somerset in 1993 and went on to become one of the finest County players. He retired in 2019 and has a stand named in his honour.

The Somerset Cricket Museum was established in 1985 and can be found in the County Grounds.

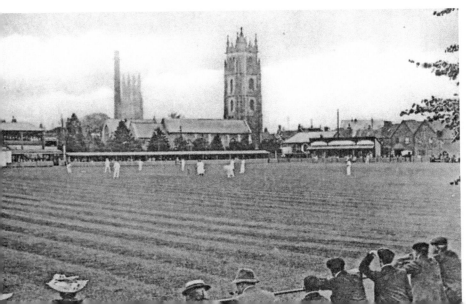

An old photograph of Somerset County Cricket Ground shows the backdrop of St James Church.

Somerset Space Walk

Situated along the Bridgwater and Taunton Canal is a sculpture trail that encourages you to contemplate the scale of the solar system in the most effective way. Along 14 miles of the canal towpath lies a 1:530,000,000 scale model of the solar system (which means that 1mm on the ground equates to 530km), with the scaling applying to both the sizes of the planets and the distances between them.

The concept was created by a local astronomer, Pip Youngman, who wanted to share his connection and fascination with the universe. His dream was realised by the Taunton Solar Model Group and the British Waterways Board in 1997 and has been open to explore ever since.

The centre of the walk is located at Higher Maunsel Lock. Here lies the sun, which is represented by an 8-foot high, 14-ton sphere of yellow concrete. Starting at this point, you can walk in either direction for 7 miles along the canal, with each route taking you past the nine planets ending at Pluto in both Taunton and Bridgwater. Incidentally, on the scale of the model, Pluto is the size of a garden pea.

Each planet has a pillar, which also acts as a milepost showing the distance to both towns. There is an inscription on each with some interesting and whimsical observations by Pip. For instance, the plaque on Earth reads:

> Earth orbits far enough from the heat of the Sun for water to be liquid, near enough not to freeze, for air to be a gas and earth solid. With gravity strong enough to hold our atmosphere, gentle enough to allow delicate life forms. Rotating to give our day and night, tilted to give the four seasons. Enormous to us, tiny on the cosmic scale. Our home, unique, beautiful, fragile.

The Somerset Space Walk begins with an 8-foot-high sculpture of the sun.

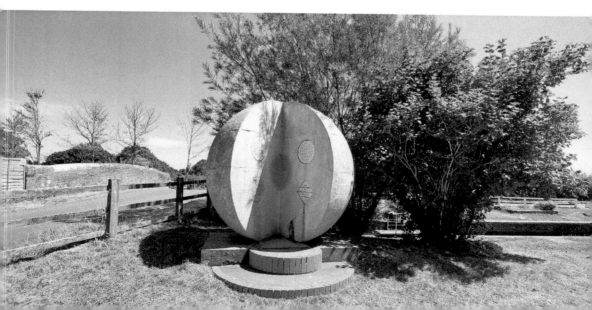

Above left: Earth is comparatively the size of a conker.

Above right: Situated 2 miles outside of Taunton, the Stonegallows boulder marks the town's execution site from 1575 until 1810.

Stonegallows

At the boundary of the parishes of Bishops Hull, Trull and Wilton stood the gallows that served as the site of execution for the town until 1810. Its location is marked today by a boulder adorned with a plaque that commemorates Stonegallows' part in Taunton's history.

The origin of the name Stonegallows is disputed, with some claiming that the name is derived from a boulder that sat beneath the scaffolding, whilst others say that the gallows were constructed in an unusual fashion with two stone uprights and a wooden crossbeam. Ultimately it is unknown which version is true, but the name has been lended to the residential road upon which it sits.

The first appearance of Stonegallows in official records comes from 1615, when it was noted that the gallows were rebuilt with timber from the village of Trull, with the first recorded execution occurring in 1624. However, it is believed that the gallows could have been in use from as early as 1575. The gallows were probably removed in 1814, four years after the final recorded execution, following protests from residents.

Taunton and Somerset Hospital

To coincide with King George III's jubilee, the Taunton and Somerset Hospital was opened in 1812 on East Reach. It was a voluntary hospital, opened at the instigation of Dr Malachi Blake, a Christian Reformer, and was supported by local subscriptions and donations.

The hospital originally accommodated twenty-six people, increasing to 100 by 1872 with the addition of side wings. In 1888 a nursing institute was built next to the hospital, to celebrate Queen Victoria's jubilee. The money was raised by an appeal from Dr Edward Liddon and Dr William Kelly.

The building is now an office block as the town's hospital moved to Musgrove Park. The Musgrove Park Hospital was originally set up as a Second World War military hospital in 1942, becoming a General Hospital with the National Health Service in 1951.

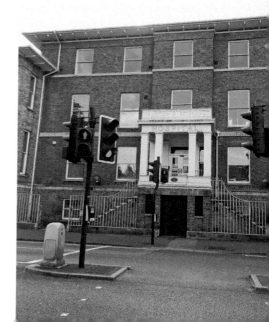

The hospital is now an office block.

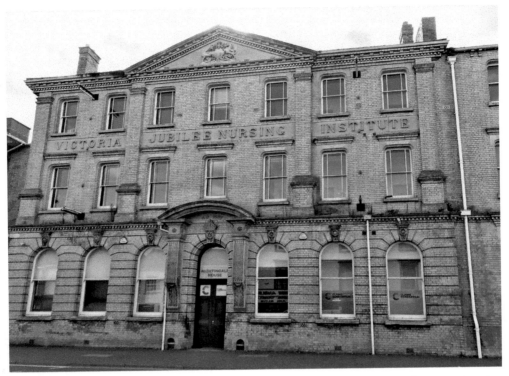

The next-door nursing institute was opened to celebrate the Golden Jubilee of Queen Victoria.

Taunton Brewhouse Theatre

The theatre opened on 28 March 1977 on the banks of the River Tone, just down from Tone Bridge. It was an old industrial site, originally used to stretch and dry cloth, then later used for coal storage and as an orchard (the address is Coal Orchard). In the latter years of the nineteenth century it was the site of a brewery business.

When the theatre opened, it was the culmination of a long campaign to find a suitable location and to raise the necessary funds to provide the town with an auditorium for live productions. Seating 350 people, the building was designed by a local architect, Norman Branson. The first professional production was Alan Ayckbourn's *The Norman Conquests*, starring David Jason, the as-yet-unknown star of *Only Fools and Horses*.

A mural by painters Tom Sledmore and Jack Tierney was commissioned for the theatre's fortieth anniversary. On the side of the building and entitled *Perchance to Dream*, it shows a variety of different aspects of theatre including a skull from *Hamlet*, Tommy Cooper's fez, Charlie Chaplin and a child watching a performance.

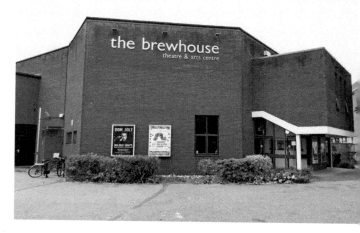

Taunton Brewhouse Theatre is on the banks of the River Tone.

The 40th anniversary mural brings a splash of colour.

Taunton Castle

There is no better representation of Taunton's importance in Somerset, if not the whole of the South West, than the remains of the castle that stands at the town's centre. It is also a more prominent reminder of the significance of Taunton's contribution to the history of England. It has seen the rise and defeat of rebellions, and witnessed some of the bloodiest court trials in the country. After almost a millennia of standing by the river, and countless additions and alterations, the castle now plays host to the Museum of Somerset.

The site was first settled during the Anglo-Saxon period, with evidence of a church and associated residences for ministers. However, the castle, as we know it today, has its roots in the early twelfth century, when it was constructed by William Gifford, the Bishop of Winchester, and then his successor, Henry de Blois. As the centuries passed, the castle continued to be altered and extended.

Initially, the castle operated as an administrative centre and status symbol for the incumbent bishop, with the occasional hosting of royal guests. From the twelfth to the fourteenth centuries, the castle was almost entirely untouched by war, although it was used to garrison troops for the King. This changed during the Wars of the Roses, with the castle being besieged in 1451 on behalf of Henry VI. During Henry VII's reign, the castle was briefly occupied by rebels supporting Perkin Warbeck, who claimed to be the younger of the two princes supposedly held captive and killed in the tower by Richard III.

From September 1644 to July 1645, during the Civil War, the site was defended by Bridgwater-born Parliamentarian Robert Blake, against Royalist sieges. Taunton was of strategic importance because it controlled the main road from Bristol to Cornwall and was a valuable centre of communications. Blake is said to have declared that he had four pairs of boots and would eat three pairs before he would surrender Taunton.

Perhaps most notably however is the castle's role in the Monmouth Rebellion. Following the Civil War, the predominantly Parliamentarian residents were unhappy with the restoration of Charles II as King, leading many to support the claim to the throne of the Duke of Monmouth. In 1685, the Duke's rebellion was defeated at the Battle of Sedgemoor and the Great Hall became the setting of the Bloody Assizes: ruthless trials of the rebellion's supporters overseen by the infamous Judge Jeffreys.

The castle was sold to Sir Benjamin Hammet in 1786, who began its restoration. In 1874 it was purchased by the Somerset Archaeological and Natural History Society, wanting to establish a museum in the Great Hall. This museum, recently refurbished, contains galleries that illustrate the evolution of the surrounding area, from 400 million years ago through to the first settling of humans and finally where we are now. It also houses the Somerset Military Museum, a gallery dedicated to the regiments of the county.

Look out for the *Sword in the Stone* sculpture located just outside the castle, by the footbridge down to the river, a nod to the legend of King Arthur so deeply embedded in Somerset.

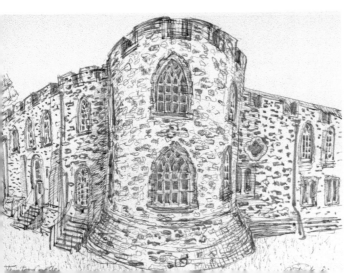

A painting of Taunton Castle.
(© Aidan Sakakini)

The Museum of Somerset is now housed in the castle's Great Hall.

It's hard to walk past this sculpture without attempting to pull out the sword.

Taunton School

Taunton School was founded in 1847 on Wellington Road before moving to a larger location in 1870 on Staplegrove Road. It originally opened as a boys-only school for dissenters, but in 1976 it merged with a nearby girls' school and became one of the earliest fully co-educational independent schools.

Taunton Stop Line

When France fell during the Second World War, plans were put in place to slow down or even put a stop to a German advance should they land on the south coast. Running for nearly 50 miles through Somerset and Devon, the Taunton Stop Line was one of more than fifty similar defensive lines that were constructed around England.

A pillbox along the canal towpath.

By early 1942, the Taunton Stop Line was defended by pillboxes, machine gun, and anti-tank emplacements, road and rail blocks, ditches and infantry trenches. At one point, every canal bridge was planted with explosives ready to detonate simultaneously should it be necessary to halt invaders. Part of the route was the Bridgwater and Taunton Canal, and you will no doubt come across some of the structures when walking along the towpath.

Temple Methodist Church

The town's Methodists were worshipping in the Octagon Chapel in Middle Street, opened in 1776 by John Wesley. But numbers were growing and by the turn of the nineteenth century, they were in need of a larger chapel.

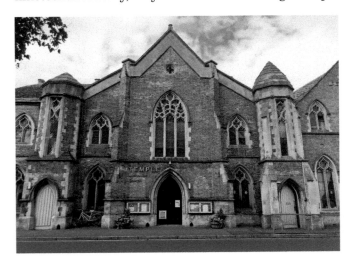

The Temple Methodist Church is a large, imposing building.

James Lackington, a wealthy bookseller, had just returned to Taunton having made his fortune in London. He built the Temple Methodist Church on Upper High Street in 1808, naming it after his London bookshop, Temple of the Muses. It was enlarged in 1846 and the front was rebuilt to a design by J. Wilson of Bath. The chapel attracted a large congregation and in 1898 General William Booth, founder of the Salvation Army, preached in the Temple.

The Temple had a thriving Sunday school and by 1874 the Wesleyan School opened in the building. It achieved enviable results, but the minimal space available and lack of a playground led to the school's closure in 1907.

Tone Bridge

Designed by J. H. Smith, Tone Bridge was built in 1895, replacing a stone medieval bridge at the end of North Street.

The iconic Taunton bridge is a magnificent, large girder construction, supported by two rows of circular columns complete with the Taunton borough's coat of arms. There are four double globe lamps, part of the early electric street lighting that was installed. The lamp posts are elaborately decorated with entwined dolphins and scallop shells, scrolled foliage and finials.

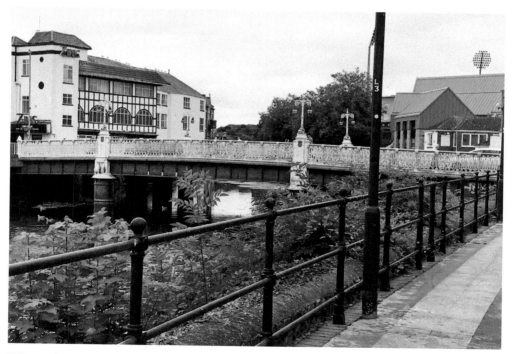

What is thought to be the UK's first Pride Rainbow Path runs by the river up to Tone Bridge.

One of the four double globe lamps that light up the bridge.

Joshua Toulmin

Joshua Toulmin (1740–1815) is the author of one of the oldest surviving history books of Taunton, written in 1791.

Toulmin was born in London but moved to Taunton in 1765, aged twenty-five years. He was Baptist minister at Unitarian Chapel on Mary Street and also taught at the school next door to the chapel. He gained the reputation as a religious radical through some of his writings which expressed his anti-England sympathy with both the American Revolutionary War and the French Revolution, views which were dimly looked upon.

In 1790, Toulmin carried out a census of Taunton and 'counted nearly five and a half thousand people living within the area ringed by the turnpike gates'. His book, *The History of Taunton in the County of Somerset*, followed the census and was published in 1791. There is a copy of the book in the library.

Toulmin left Taunton in 1804, moving to Birmingham where he died in 1815.

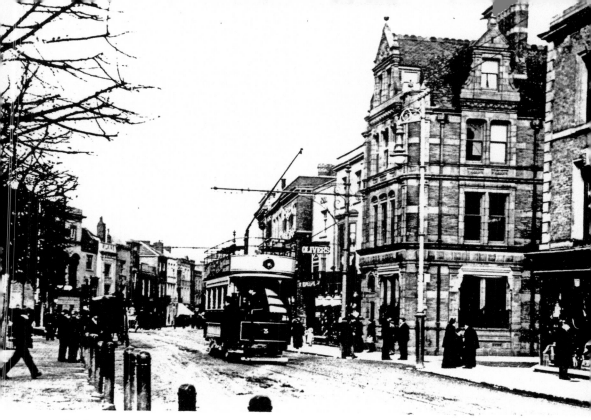

An electric tram in Fore Street *c.* 1902. (© Electrical Historical Society)

Trams

Taunton had an electric street tramway in operation from 1901 to 1921.

It started life as the 'Taunton & West Somerset Electric Railways and Tramways Company' before being shortened in 1903 to the more manageable 'Taunton Electric Traction Co. Ltd'.

The plan was to eventually have a network which would extend to neighbouring towns such as Wellington. Originally the line ran between the railway station and East Reach, using six double-deck cars which were later exchanged for single-deck trams. In 1909, a second phase extended the tramway a little way beyond the station but, at just over 1.5 miles, it was still the shortest tramline in England.

The electricity required came from a new generating station sited in St James Street. Unfortunately, the rising price of electricity following the First World War ultimately forced the closure of the trams: in 1921 the council cut off the company's electricity supply for failure to pay their bills.

Unitarian Chapel

A relatively new approach to religion, Unitarianism grew out of the Protestant Reformation of the sixteenth century.

The Unitarian Chapel on Mary Street was built in 1721. In line with the belief system towards social justice and community work, the congregation of the chapel placed great importance on ensuring children from poor families were given the opportunity of a free education, and this included girls as well as boys. As such, a school was built next to the chapel and ministers, including the historian Joshua Toulmin who was its Minister for many years from 1765, would frequently teach in the classroom. A larger school was built on the site in 1886.

Notable lay preachers at the chapel included John Wesley, Dr Malachi Blake (who founded the Taunton & Somerset Hospital), and Samuel Taylor Coleridge who was living in the village of Nether Stowey 11 miles away. Coleridge came to preach at the chapel on several occasions, and in the spring of 1798, he temporarily took over from Revd Joshua Toulmin, who was grieving the death of his daughter from drowning.

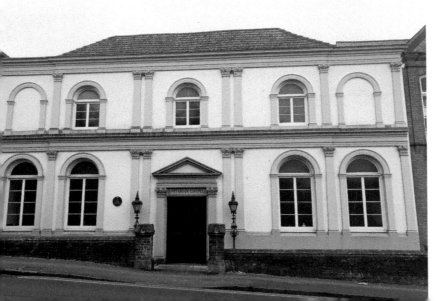

The Unitarian Chapel on Mary Street.

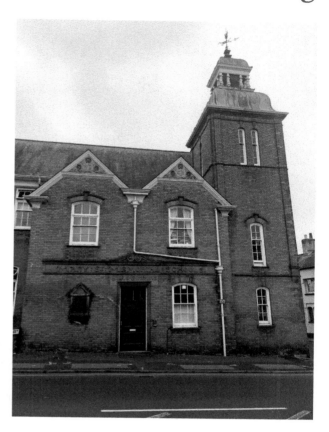

A school was built next to the chapel, providing free education to poor families.

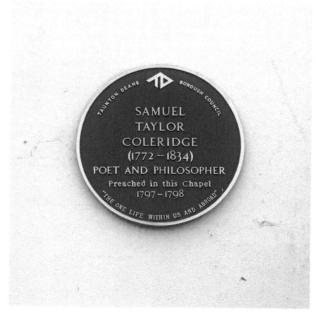

The chapel attracted several visiting preachers of note.

United Reform Church

The United Reform Church, a large red brick building on Paul Street, is the former Congregational church. The present Grade II listed building dates from 1797 and is considered a fine example of a nineteenth century Meeting House.

In 1662, a Cavalier parliament under Charles II imposed the Act of Uniformity upon the church, or, to give it its full title: *An Act for the Uniformity of Public Prayers and Administration of Sacraments, and other Rites and Ceremonies, and for establishing the Form of making, ordaining and consecrating Bishops, Priests and Deacons in the Church of England.*

This effectively regulated worship in the Church of England and required, amongst other things, all ordained clergy to follow the Book of Common Prayer. Those clergymen who felt unable to comply were cast out of their pulpits and named 'dissenters'.

Two of the 2,000 dissenters were George Newton, Vicar of St Mary Magdalene Church, and his curate, Joseph Alleine. Both defiantly continued to preach, risking imprisonment, until in 1672 the Act of Toleration issued by Charles II made it possible for 'non-conformist' churches to meet in England. The site on Paul Street was bought and 'Paul's Meeting House' was built, with George Newton as the first minister.

The Church joined the Congregational Union in 1832 and in 1972 the Congregational and Presbyterian Churches joined together, forming the United Reform Church.

The United Reform Church dates from 1797.

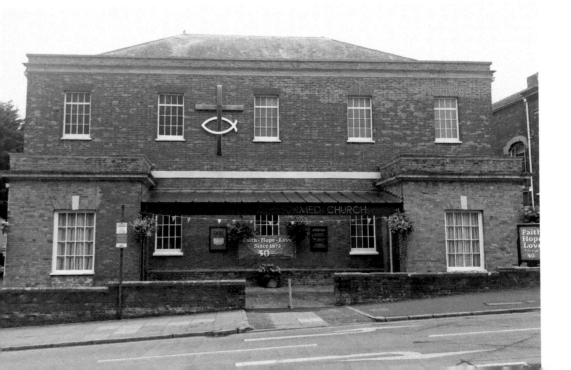

V

Vivary Park

Close to the top of the high street is Vivary Park, an elegant public park complete with children's playgrounds, tennis courts, a model railway track, high ropes adventure centre, miniature golf and even an 18-hole golf course. The Sherford Stream, a tributary of the River Tone, flows through the park.

Historically the land was used as a medieval fish farm or vivarium – hence its name, Viviary Park, a nod to its origins. The Bishops of Winchester kept two fishponds which were used to supply the Priory and the castle with fresh fish. Records show that bream, pike and eel would have been on the menu. There is no sign of the original lake but during the 1980s a new one was created, named Wilton Lake. It not only adds an interesting feature but has also become a home for plenty of wildlife including kingfisher, moorhens, ducks and even otter.

During the eighteenth century the park was incorporated into an estate which included Wilton House. In 1810, William Kinglake bought the estate and began to open the grounds for public events. These included the Taunton Deane Horticultural and Floricultural Society show in 1851 and the first Bath and West Show in 1852.

Taunton Deane Borough Council bought the park from the Kinglake family in 1894 for £3,659 and improvements began in earnest as the park was laid out.

Features of Vivary Park

Entrance to the park from the High Street is through handsome cast-iron entrance gates which incorporate the borough coat of arms. These were supplied in 1895 by Saracen Foundry in Glasgow, and in June of the same year the bandstand was completed, in time for the first concert in the park given by the Taunton Town Band.

An ornate fountain was commissioned as a memorial to the late Queen Victoria and was unveiled on 31 October 1907.

The Vivary War Memorial dates from 1922. Beautiful white stone with a domed roof, the memorial contains more than 600 names of those who served in the First World War, the Second World War and the Northern Ireland Conflict. The surrounding gardens and flower beds were laid out in 1926. The stunning rose garden became a regional trial ground for the Royal National Rose Society during the 1960s (now known as The Rose Society UK).

Above and left: Both the entrance gates and the bandstand were made by the Saracen Foundry in Glasgow.

Right: The Queen Victoria Memorial Fountain.

Below: The Vivary War Memorial is to the left. In the distance you can see a glimpse of the Jellalabad Barracks.

In 1928 the Vivary Golf Club, designed by Herbert Fowler, was laid out adjacent to the park, and in 1979 a model railway track was added to the park.

In 1997 the Normandy Stone was commissioned in a secluded corner of the park, towards the boundary of Wilton House. It commemorates those who took part in the Normandy Campaign in 1944. There are three trees behind the stone which were planted to represent the beaches Sword, Juno and Gold.

In 2010 the old boating lake was reopened as a sensory garden funded by a £22,000 grant from the Community Spaces and Groundwork UK fund. There is also a memorial stone in the sensory garden to remember Royal Marines from 40 Commando who were killed during a six-month deployment to Afghanistan in 2010.

After over a century of public use, the park was showing signs of deterioration. It was restored in 2002 at a cost of £750,000, with assistance from the Heritage Lottery Fund, and was officially reopened on 2 May by Her Majesty Queen Elizabeth II during her Golden Jubilee Tour. A real bonus for the town, the park still retains much of its Victorian character and is as lively and full of activity as ever.

The Normandy Stone memorial is on the boundary with Wilton House.

A memorial stone in the sensory garden was commissioned for the Royal Marines from 40 Commando.

Perkin Warbeck

In 1497 a man named Perkin Warbeck attempted to overthrow Henry VII and put himself on the throne as the rightful heir. He claimed to be one of the missing princes in the tower, Richard, Duke of York, nephews of Richard III who had been defeated in battle by Henry VII.

He raised a Cornish army of 8,000 men and entered Taunton in 1497. His forces were rebuffed by the King's army and Warbeck was imprisoned and cross-examined in Taunton Castle. He was subsequently hanged in London in 1499.

Joseph Whidbey

The prominent grave of Joseph Whidbey (1757–1833) is in the St James Church graveyard. A remarkable man who retired to Taunton in 1830, Whidbey was an engineer and explorer who had accompanied Vancouver to the Caribbean in the 1780s and on his journeys to the Pacific Ocean in the 1790s. Captain Vancouver named an island in the Pacific Northwest after Whidbey.

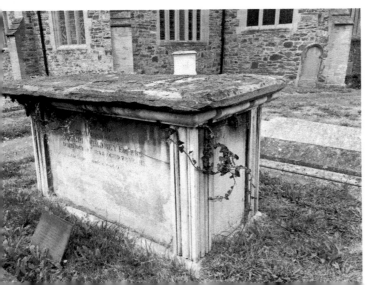

The grave of Joseph Whidbey is in St James Church graveyard.

He was later key in the planning and construction of Plymouth Breakwater during the Napoleonic Wars, with the aim of creating a safe harbour for the Royal Naval ships. A feat of nineteenth-century engineering, the foundation stone was laid on Shovel Rock on 8 August 1812. It is said that around four million tons of rock were used in its construction at an eye-watering cost of £1.5 million, which would be equivalent to approximately £106 million today.

Whidbey retired to Taunton in 1830 and lived at St James House where he died on 9 October 1833.

Wilton Gaol

Wilton Gaol has several alternative names: Taunton County Bridewell, Wilton Bridewell, Wilton County House of Correction, Taunton County Gaol, Taunton Prison.

Prior to the Wilton Gaol, there were two prisons called The Cow House and Little Ease built beneath the Guildhall (now the Market House) in 1467. In the late 1500s, the House of Correction was next to Tone Bridge.

Wilton Gaol was built in 1754 on what is now Upper High Street. The county gaol at that stage was in Ilchester, so this was to be used primarily as a house of correction. Men, women and children would spend time here following sentences by county magistrates for petty offences such as pick-pocketing, prostitution and begging. It was a forerunner to the workhouse. Two famous penal reformers visited Wilton Gaol: John Howard in the 1770s and Elizabeth Fry in 1825.

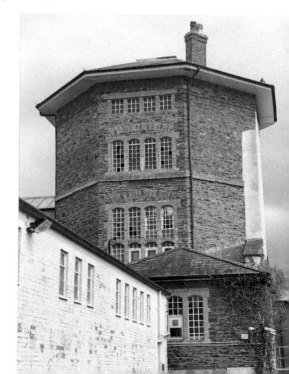

The distinctive octagonal observation tower commanded views over the exercise yards.

It was enlarged and renovated over the years and by 1843 there were separate cells for 275 prisoners as well as a chapel, schoolroom and workshops. Women undertook chores of washing, ironing and needlework. Prison labour included a treadwheel which was used to grind wheat and corn.

It became the county gaol in 1843 following the closure of Ilchester County Gaol. This meant it could hold those who had been convicted of serious crime and were awaiting punishment, as well as being the site for executions in the county.

Sixteen murderers were hanged at Wilton Gaol, many attracting large crowds of onlookers. 3,000 were reported to have watched the execution of Joel Fisher, a veteran of the Battle of Waterloo, who at the age of fifty murdered his wife, Mary, in front of their children and a servant girl.

In 1884, Shepton Mallet Prison became the County Gaol and the site in Taunton was used as a military prison, before eventually becoming the headquarters of the Somerset Constabulary.

Wilton House

Wilton House is a substantial house, built in 1705. At the time, it was part of an estate which included parkland stretching away from the town towards the Blackdown Hills.

In 1810 a local lawyer, William Kinglake, bought the park and twenty-roomed house. He provided the grounds for different public events including the Bath & West of England Agricultural Show 1852. The Kinglake family sold the park to Taunton Deane Borough Council in 1894. The house is now a care home which opened in 2011.

Vivary Park originally formed the estate of Wilton House.

Workhouse

Under the Poor Law Amendment Act of 1834, England and Wales were divided into unions of parishes, and each one was required to build a workhouse to house the people in its area who were in need of help.

Taunton was one of seventeen unions in Somerset, and the Taunton Union workhouse was built in 1836–38 on what is now Trinity Road. The architect was Sampson Kempthorne, an English architect who specialised in workhouses. The design was based on his standard hexagonal plans which made it possible for able-bodied men and women and elderly and infirm men and women to be kept apart. Each group had its own exercise yard that was surrounded by high walls. A two-storey block was later added.

Conditions in workhouses were harsh, and the majority were overcrowded and insanitary. In 1849 an outbreak of cholera in the Taunton Union workhouse was put down to the diet, ventilation and cramped conditions.

In 1930 a new Local Government Bill abolished all the Poor Law Unions and passed the responsibility to county councils and county boroughs. Taunton Union Workhouse was taken over by the local authority and renamed the Taunton Public Assistance Institution. With the arrival of the National Health Service in 1948 it became Trinity Hospital before closing in 1993.

Most of the original building has been demolished, except for the front entrance block which is now residential accommodation.

This is the entrance block to the former workhouse. Little else remains of the original building.

XIII – Somerset Light Infantry

The Somerset Light Infantry was one of nine regiments of foot raised by James II in 1685 to increase the size of the army in order to address the Monmouth Rebellion.

Since then, the regiment has gone through several reincarnations – from the 13th Regiment of Foot (from 1751) to the 13th Somersetshire Light Infantry (from 1782), before being awarded the honour in 1842 of being re-titled the 13th or Prince Albert's Light Infantry following the conduct of the 13th at Jalalabad, Afghanistan.

In 1959 the regiment was amalgamated with the Duke of Cornwall's Light Infantry to form the Somerset and Cornwall Light Infantry. Further amalgamations through the years finally led to the formation of The Rifles in 2007.

The Somerset Military Museum in The Museum of Somerset holds regimental archives of the Somerset Light Infantry. A key part of Taunton's history, there are also memorials relating to the regiment in the Soldiers Corner at St Mary Magdalene Church.

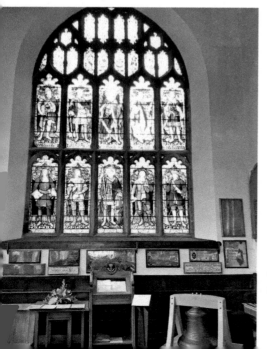

The Soldiers Corner in St Mary Magdalene Church.

Y

Yea Family

The Yeas were a prominent local family. In 1756 Sir William Yea and his wife, Julia Trevelyan of Nettlecombe, built Pyrland Hall, a Grade II* listed country house. It has changed hands several times over the centuries and from 1952 has housed the prep school of King's College.

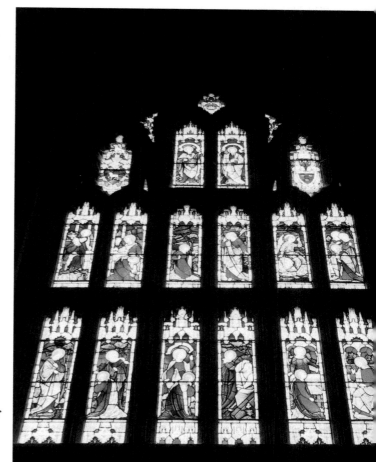

The Mary window at St James Church, in memory of Louisa and Charlotte, daughters of Sir William Yea.

St James Church holds a couple of interesting memorials for the Yea family. The West window, situated over the main door into the church, is the Mary window: each of the scenes depicted includes a Mary from the New Testament.

The window is in memory of Louisa Yea and her sister Charlotte (Grant), daughters of the first Baronet, Sir William Yea, and was donated under the terms of Louisa's will. Unfortunately, the amount that was allocated was insufficient to cover the cost, so the remaining amount was covered by the Grant family.

The marble memorial for Colonel Lacy Walter Giles Yea in St James Church.

There is also a magnificent memorial which commemorates Colonel Lacy Walter Giles Yea who served with the 7th Royal Fusiliers. He was killed in action at the age of forty-seven on 18 June 1855 while leading his men in the attack on the Redan at Sebastopol in the Crimean War. A well-liked and respected officer, his men risked their own lives to bring his body back.

Yea was praised by Lord Raglan who said in his despatch the following day:

> Colonel Yea was not only distinguished for his gallantry, but had exercised his control of the royal fusiliers in such a manner as to win the affection of the soldiers under his orders, and to secure to them every comfort and accommodation which personal exertions could secure for them.

His eldest sister organised the marble monument to him in the church, whilst a headstone marks his grave in the cemetery at Sevastopol.

YMCA Gymnasium

The YMCA (Young Men's Christian Association) was founded by Sir George Williams. A worker in the drapery trade in London, he was concerned about the welfare of his fellow workers and so began a prayer and Bible study group. In the early 1880s, the British YMCA began to incorporate personal fitness into its programmes. The YMCA Gymnasium opened on Middle Street in 1895.

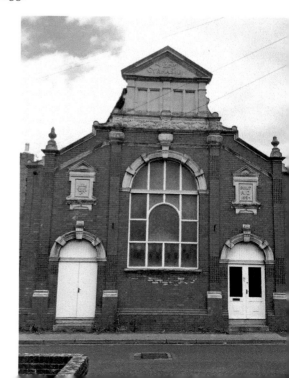

The YMCA Gymnasium on Middle Street.

Zodiac

This final entry is rather curious.

According to an old newsletter of St James Church, there were once fourteen carved, wooden ornamental bosses on the beams supporting the south aisle ceiling, twelve of which were carved with signs of the zodiac. Sadly they no longer exist, and there seems to be little information on them. An ongoing mystery....

Acknowledgements

I am indebted to the following for their incredible material that has proven such a source of inspiration: the Electricity Historical Society, the Museum of Somerset, St James Church, St Mary Magdalene Church, the Somerset Industrial Archaeological Society, the Somerset Heritage Centre and the Taunton Visitor Centre. J. Savage's *History of Taunton* also provided some wonderful nuggets of information.

I would like to thank the following organisations for permission to use images in this book: the Castle at Taunton, the Electricity Historical Society, Hestercombe House & Gardens, King's College Taunton, the Royal Bath & West of England Society, the *Somerset County Gazette*, the Taunton Flower Show and Taunton Heritage Trust.

Whilst I'm responsible for the remainder of the images, if I have inadvertently used copyright material without acknowledgement I apologise and will make the necessary correction at the first opportunity.

I would also like to give a special thanks to the talented artist Aidan Sakakini, for the paintings he did specifically for the book. If anyone is interested in prints, please get in touch andrea@murfdog.co.uk.

Last, but by no means least, I must also thank my husband and sons for their patience and support.

Corner of High Street.
(Aidan Sakakini)

About the Author

Andrea Cowan has lived in Somerset for the last fifteen years and has thrown herself into the history and traditions of this diverse and fascinating county. She combines her ongoing career in PR with the world of journalism and writes regularly for local publications, drawing on the wealth of material that living in Somerset provides. *A–Z of Taunton* is her first book.